POSTCARD HISTORY SERIES

Winston-Salem

IN VINTAGE POSTCARDS

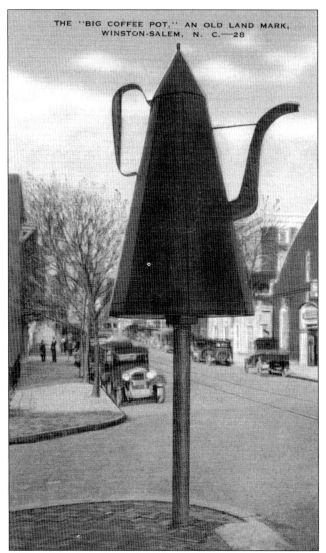

THE BIG COFFEE POT. A common sight both on postcards and all around Winston-Salem is this tall structure that looks like a coffee pot. The coffee pot is viewed as a symbol of hospitality. It was built in 1858 by tinsmith Julius Mickey to advertise his tin shop. The coffee pot was chosen because it was a familiar sight in homes and easily recognizable. It originally stood on a wooden post at the corner of South Main and Belews Street. Occasionally, a wagon would accidentally knock it across the street. Once, a car hit the coffee pot so hard that it fell along the sidewalk, barely missing a woman and child walking nearby. The structure was badly damaged and removed for repair. Town officials argued that it should not be put back—it was a danger and was also an advertising sign, which was not allowed by law. Citizens protested the decision and Bishop Rondthaler declared that he considered the coffee pot a historic landmark and its loss would be unthinkable. Town officials reconsidered and declared that the great tin vessel was a street marker, a landmark, and a historic relic. It was replaced, on a sturdier post, farther from the street. The coffee pot stood in the path of Interstate 40 and was moved down the street in 1959 to its new home between the Salem By-Pass and South Main Street, where it remains the symbol of hospitality in Winston-Salem.

POSTCARD HISTORY SERIES

Winston-Salem

IN VINTAGE POSTCARDS

Molly Grogan Rawls

ARCADIA

First published 2004
Reprinted 2005

Published by Arcadia Publishing
Charleston SC, Chicago IL, Portsmouth NH, San Francisco CA

Printed in Great Britain

Library of Congress Catalog Card Number: 2004104926

For all general information contact Arcadia Publishing at:
Telephone 843-853-2070
Fax 843-853-0044
E-mail sales@arcadiapublishing.com
For customer service and orders:
Toll-Free 1-888-313-2665

Visit us on the internet at http://www.arcadiapublishing.com

This book is lovingly dedicated to my husband, Jeffrey Dwight Rawls; to our sons, Curtis Grogan Rawls, Allen Worthington Rawls, and Kevin Mackie Rawls; and to my parents, Joseph Cherry Grogan and Angelia Mackie Grogan. I appreciate your enthusiastic support and encouragement in all my endeavors, and particularly with this book.

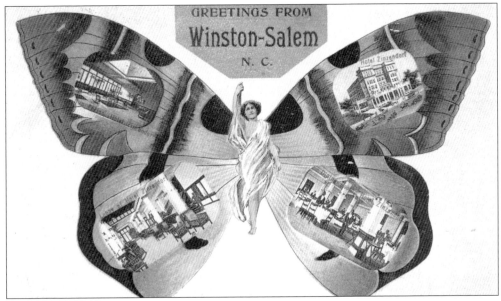

BUTTERFLY GREETINGS FROM WINSTON-SALEM. The colorful butterfly advertises the Zinzendorf Hotel on Main Street on her wings. The four scenes depict the hotel's exterior, dining room, lobby, and sun parlor. Each of these images was made into individual postcards. This type of postcard was made in the early 1900s for many cities, using the butterfly, a flower, or another background showing views of the city.

Contents

ACKNOWLEDGMENTS

Deltiologists, or postcard collectors, enjoy talking about their collections. I am privileged to have met many deltiologists in the process of compiling this book and appreciate their willingness to share the bounties of their collections to show the wide range of Winston-Salem vintage postcards. Each collection that I viewed offered unique images, often reflecting the special interests of the collector. Individual acknowledgements are included in the postcard captions.

My thanks go to Clarke and Della Stephens, who allowed me to examine their extensive collection on several occasions and were very patient while I copied many of their postcards. Sarah Murphy McFarland loaned me her postcard collection and shared some of her stories about finding the postcards. Sherry Joines Wyatt offered her booklet of postcards that enriched this compilation.

Evelyn Shaw Styron treated me to interesting conversations about her collections and generously shared her postcard collection. Stephen E. Massengill loaned several postcards from his private collection. My neighbor, Sylvia Yarnell, allowed me to borrow postcards sent to her from her father when he visited Winston-Salem.

Wayne and Louise Biby offered the use of their collection, including the postcard that is printed on the back cover. George Hege shared a family postcard collection that included several local churches. Julian Harris permitted me to examine his extensive collection and loaned several postcards for this book.

Many of the postcards came from the Forsyth County Public Library, where I work as the photograph collection librarian. Merrikay Brown, on behalf of the Lewisville Historical Society, allowed me the use of the Lewisville High School postcard and provided the history of the school. I am also grateful to Universal Services Inc. for granting permission to publish the "Russell King's Thruway Gulf Service" postcard.

The remainder of the postcards came from my personal collection that began with cards I received from my mother when I was a freshman in college. She regularly mailed letters, keeping me informed about home activities and about my three brothers, Joe Jr., John, and David. The postcards were for quick notes, between letters. Since then, I have added many cards to my collection, but these cards with news from home mean the most.

My husband, Jeffrey, assisted in every phase of the book, particularly with preparing the postcards for publication. He also read the manuscript and offered valuable suggestions. My parents, Joe and Angelia Grogan, provided historical information and gave substance to written accounts. There is no substitute for being able to discuss the city's history with those who experienced it.

I am also indebted to our city's historians, the individuals who have taken the time to research the past and to record the events of the present so that later researchers will have reliable tools for writing books with a historical emphasis. Many of these historians and their publications are listed in the bibliography.

INTRODUCTION

Postcards say a lot about a city and the people who live there. They show images that the sender deems important, and they send messages that relay information, make inquiries, or just extend greetings. Whatever the original purpose, postcards show and tell a city's history. This compilation of vintage Winston-Salem postcards brings them back to their origination; they have come home.

Winston-Salem, North Carolina, is the county seat of Forsyth County. The county was formed in 1849 from adjoining Stokes County. Land for a courthouse was sold to the county by the Moravians, and the town of Winston was established. The county seat could have been situated in Salem, the nearby Moravian town, but Moravian leaders objected to the rowdy activity that a courthouse attracted. The Moravians wanted the courthouse close, but not too close.

Winston-Salem gained the hyphen officially in 1913, although the two towns had shared a post office and various municipal services since the turn of the century. As the industries and trades grew, so did Winston-Salem, until it was the largest city in North Carolina, attracting people from surrounding counties to work in its factories. With new people coming to town to work and visit, the postcard became a popular vehicle to showcase Winston-Salem's attributes to the folks back home.

Some postcards traveled farther than others. Postcards addressed to Washington State, New York, Illinois, California, and Florida are not uncommon. Neither are local addresses, such as Bethania, Clemmons, Advance, East Bend, Greensboro, and Winston-Salem. It may seem a little ridiculous to send a postcard to someone in the same city, just to relay some tidbit of information or inquire about someone's health, but we forget that there was a time when the postman was the communication link, rather than the telephone or e-mail. Sending a postcard was easier than walking several blocks over muddy or dusty streets to deliver a message personally.

The oldest verifiable postcard used in the book is dated and postmarked December 1902, titled "Salem Academy and College" (page 17). There is room on the front of the postcard for a brief message and the entire back is designated for the address. This type of postcard is called the "undivided back" and was printed from 1901 to 1907. A writer had to keep the message short, or it would cover the image.

The "divided back" postcard came into use March 1, 1907, with equal portions of the card back to be used for address and message, usually with the sections appropriately marked.

Other types of postcards are linens, chromes, and real photos. Linen postcards were published in the 1930s and 1940s and appear to have a texture. One example of a linen postcard is the view of West Fourth Street (page 38) showing the Carolina Hotel and Theatre and the Nissen Building. Another example is the Forest Hills Farm Smoke House postcard (page 72). Linens were published in color, and the colors may vary with the printings.

Chrome postcards resemble a color photograph. They usually appear shiny and were sold from the 1940s to today. The views of Wake Forest College (pages 82 & 83) are chrome postcards.

Real-photo postcards were reproduced from photographic images, usually printed on request by a local photographer. The front cover image of this book is a real-photo postcard of Liberty Street, taken in 1913. Another example is the view of Fourth Street looking west (page 42). Individuals and families often had their photographs, or those of their home, printed onto postcard stock, ready for mailing. Real-photo postcards are prized in collections because of their rarity.

Sometimes a postcard is the best or only image of a building, business, or street view. For this reason, postcards are valuable visual records of a city. Unfortunately, postcards were not produced for all subjects or all areas of a town, thus limiting the coverage of this book. The author examined hundreds of postcards, from several collections, and chose the best available images that would illustrate the history of Winston-Salem.

Whether the reader is a short or longtime resident, a student residing here for a brief stay, or a guest in our city, the author hopes that this book will make Winston-Salem feel like home.

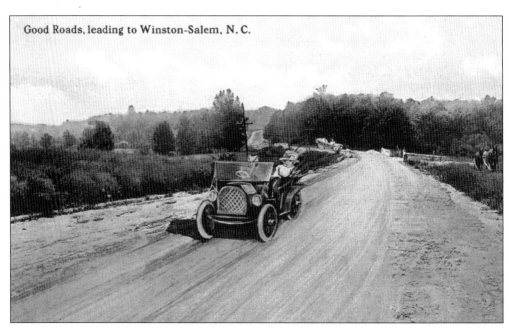

Good Roads, leading to Winston-Salem, N. C.

GOOD ROADS LEADING TO WINSTON-SALEM, NORTH CAROLINA. A statewide good roads campaign began in North Carolina in 1917, with plans made to build a network of all-weather roads connecting the county seats. Gov. Cameron Morrison, the first "Good Roads Governor," was instrumental in creating a state highway commission in 1921 to build a modern system of highways. Local funds subsidized building and maintaining the highways leading to Winston-Salem.

One
MORAVIAN BEGINNINGS

The Moravians arrived in North Carolina in November 1753, purchasing 98,985 acres and naming the land der Wachau (later called "Wachovia"). Led by Bishop August Spangenberg, the first community established was Bethabara, which means "House of Passage." The religious, German-speaking Moravians also built Bethania to the northwest.

Salem, which means "peace," was planned to be the governing seat, as well as the trading and industrial center for the Wachovia settlement. The first settlers arrived in Salem in 1772, ready to occupy the new homes and to continue the trades and professions that they had previously plied in Bethabara. The area around Old Salem was designated a historic district in 1948, and Old Salem Inc. was established in 1950. Today, visitors tour the restored Moravian village, experiencing life as it was in pre–20th century Salem.

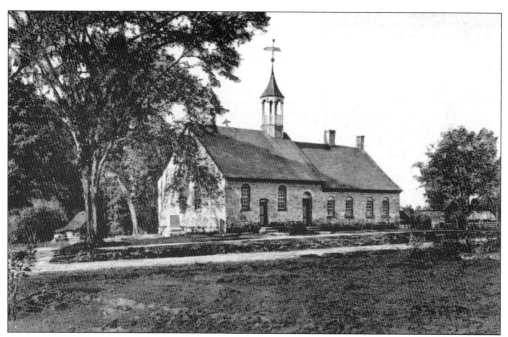

BETHABARA MORAVIAN CHURCH. The first church in the settlement was built in 1756. It was made of logs and located within the stockade. In 1788 a new church was built with stones and local, handmade bricks. The "Gemein Haus" was used by the Bethabara Moravian congregation for worship services until 1953, when they moved into the new Christian Education Building a block away.

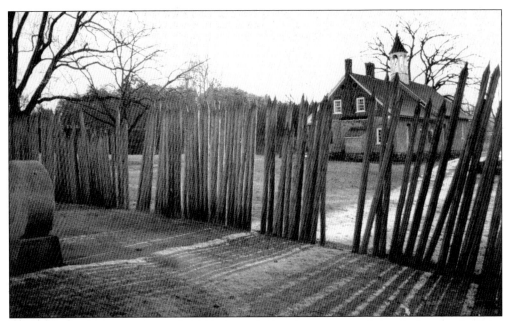

HISTORIC BETHABARA PARK. A 1964 excavation project uncovered the ditches that held the palisade posts upright at the fort site. The fort was rebuilt in 1965 and involved 2,000 12-foot poles, from 4 to 8 inches in diameter, standing 10 feet above the ground. The original "Old Dutch Fort" was built in 1756 for protection against the Native Americans during the French and Indian War and was removed in 1763.

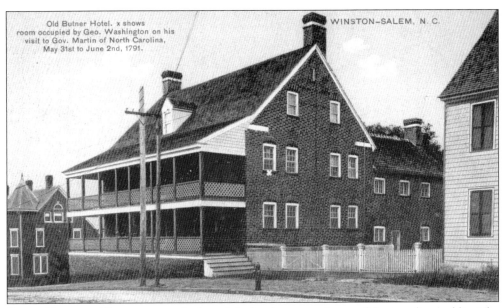

Old Butner Hotel. x shows room occupied by Geo. Washington on his visit to Gov. Martin of North Carolina, May 31st to June 2nd, 1791.

WINSTON-SALEM, N. C.

SALEM TAVERN. The tavern was built mainly for the convenience of the traveling public. The first tavern burned in 1784, and a new brick building was erected that year on the previous foundation. This postcard refers to the "Butner Hotel," named for Adam Butner, who bought the tavern in 1850. The "x" under the tavern window indicates the room that George Washington occupied during his visit to Salem in 1791.

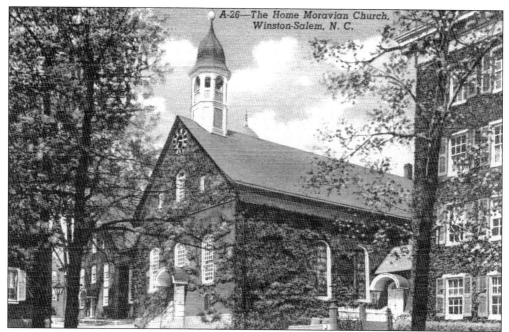

HOME MORAVIAN CHURCH. The writer of this postcard commented, "This is one of the prettiest churches in town." Designed by Frederick William Marshall and completed in 1800, Home Moravian Church is a popular postcard subject. The church is located across from Salem Square on South Church Street, near the site of the old Gemein Haus. Home Moravian first used the arched hood, called the Moravian hood, over the door.

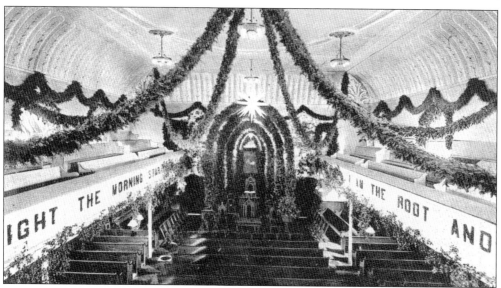

HOME MORAVIAN CHURCH INTERIOR. This 1910 postcard, published by W.H. Watkins and printed in Germany, shows the sanctuary interior arrangement. Festooned with Christmas greenery, the sanctuary is arranged without a center aisle. The 1870 renovation marked a change in seating arrangement in that the congregation no longer sat according to "choirs," or station in life. A 1913 renovation again changed the interior of the sanctuary.

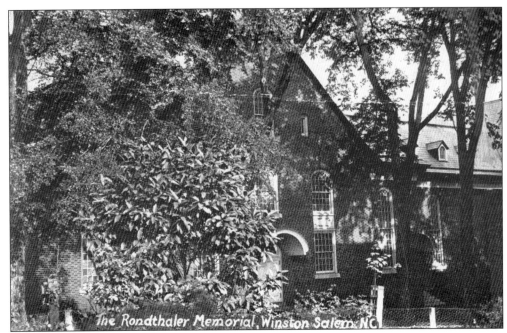

RONDTHALER MEMORIAL. The 1913 Home Moravian Church sanctuary renovation coincided with the opening of a new Sunday school building, named the Rondthaler Memorial. The new facility was named for Bishop Edward Rondthaler, who served as pastor of Home Moravian Church for 31 years. Bishop Rondthaler was born in Pennsylvania, attended Nazareth Hall, and came to Salem in 1877. He was consecrated the 184th Bishop of the Moravian Church in 1891.

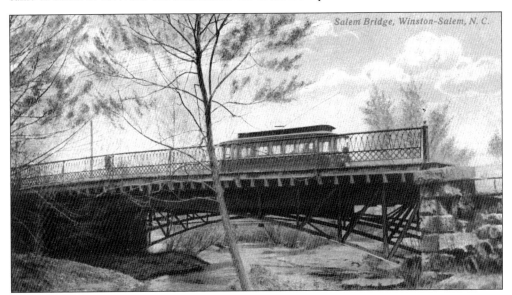

SALEM BRIDGE. In 1891 a solid stone-and-iron bridge was built over Wachovia Brook. A couple of years earlier, the Winston-Salem Railway Company was incorporated, organized by Thomas Edison and Frank Sprague. Streetcars began running in Winston in 1890. Soon, lines extended throughout Winston and down Main Street into Salem. The streetcars were nicknamed "trolleys" for the overhead pole-and-shoe mechanism that glided on the power line.

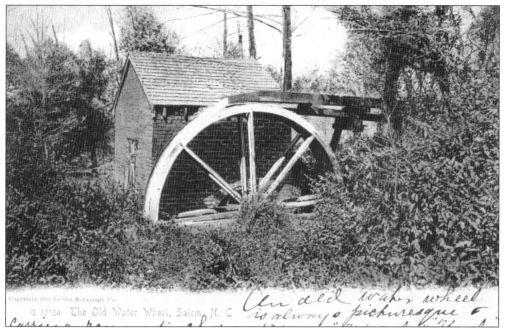

SALEM WATER WHEEL. "An old water wheel is always picturesque and carries a romantic charm to me," penned the writer of this 1906 postcard. The flowing script of the address on the undivided card back also speaks of an earlier time. Salem's water system evolved from a gravity distribution system in 1778 to a pumping station connected to a reservoir in 1901. This postcard shows the overshot water wheel.

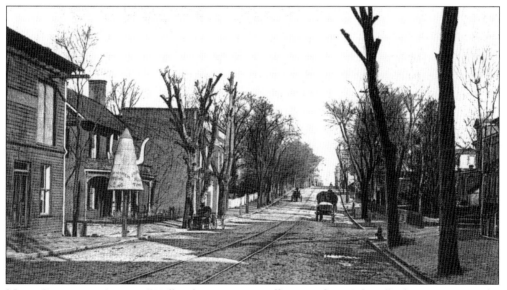

MAIN STREET IN SALEM. "Hello, do you want coffee now from Salem?" This message on the front of the postcard refers to the coffee pot on the left. H.E. Nissen, building inspector and fire chief of Winston-Salem, owned the house behind the coffee pot. The house and the coffee pot were on neighboring corners of Main and Belews Streets. The coffee pot was moved and the house demolished for Interstate 40.

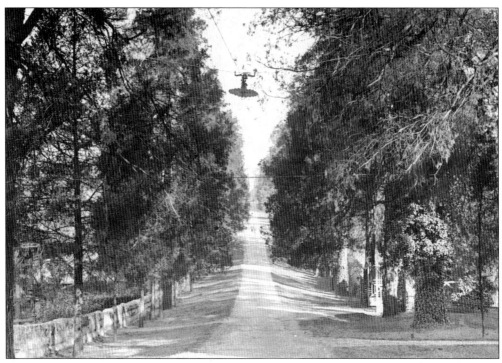

CEDAR AVENUE. The avenue beside the graveyard in Salem is a popular subject for postcards. The cards can be dated by looking closely at the trees that line the avenue. Native red cedar trees were planted there in the early 1800s, but by the end of 1918, all cedars were replaced by Laurel Oaks. Although the cedar trees were replaced, the name of the avenue remains unchanged.

The Early Easter Service

of the MORAVIANS in

WINSTON-SALEM, North Carolina

will be broadcast by the

Columbia Broadcasting System

and Local Stations WSJS and WAIR

Easter Sunday, April 5, 1942

6:00 - 7:30 a. m., e.w.t.

If you hear and enjoy the Service please send a post card to Columbia Broadcasting System, New York, N. Y., or to the Moravian Church Office, 500 S. Church Street, Winston-Salem, N. C.

THE EASTER SUNRISE SERVICE. The first broadcast for WSJS Radio was the Home Moravian Church Men's Bible Class on Palm Sunday, April 13, 1930. WSJS also broadcast the Easter Sunrise Service in Salem the following Sunday. The writer of this 1942 postcard, mailed to Nazareth, Pennsylvania, commented "Thought you might like to tune in. Easter Greetings." Moravians held the first Easter Sunrise Service in Salem's God's Acre in 1773.

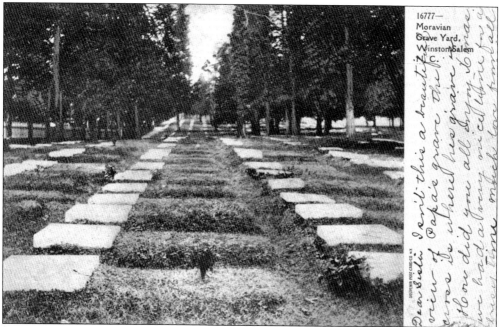

THE MORAVIAN GRAVEYARD. The site for the graveyard in Salem, called God's Acre, was selected in 1766, and the avenue bordering it, Cedar Avenue, was laid out in 1770. John Birkhead was the first person buried here in 1771. The identical recumbent white stones symbolize the Moravian belief in the democracy of death. The two postcards shown here were written in 1907 by a Moravian woman to her sister in Washington state. The postcards show how the style of postcards changed from January 1907 (undivided back, message on front) to October 1907 (divided back, message on back). The top postcard shows the unadorned graves, with a small cross drawn on one grave to indicate "Papa's grave." The bottom postcard shows the graves adorned with flowers for the annual Moravian Easter Sunrise Service that has taken place in Salem since 1773.

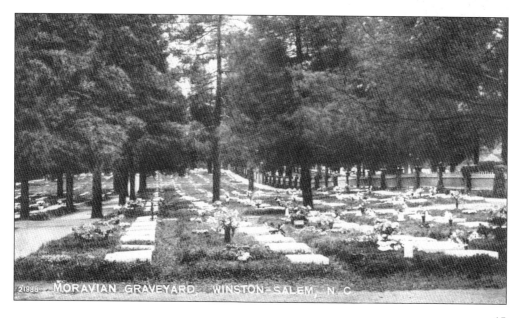

21988 MORAVIAN GRAVEYARD. WINSTON-SALEM, N. C.

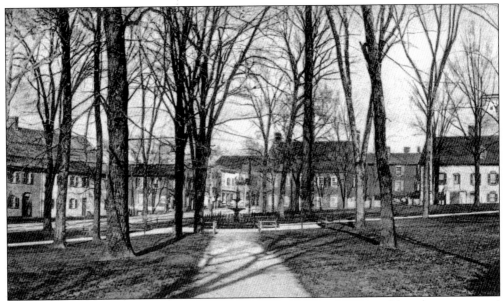

SALEM SQUARE. In Salem's early days, the principal activities and buildings were centered around the square. Established in 1768, the square was once farmed by Matthew Miksch and was later used for grazing sheep. A fountain and other improvements were added in 1890. This 1908 postcard was written to Marguerite Fries, daughter of Henry and Rosa Fries, who died in 1916 of scarlet fever.

SALEM SQUARE CISTERN. One reason for selecting the present town square location was its favorable accessibility to the water supply. A public cistern and hand pump were located in a corner of the square. The Market–Fire House was built on the square in 1803 to house the fire engines and a meat market. Water buckets were passed by hand from the cistern to the fire engine to fight a fire.

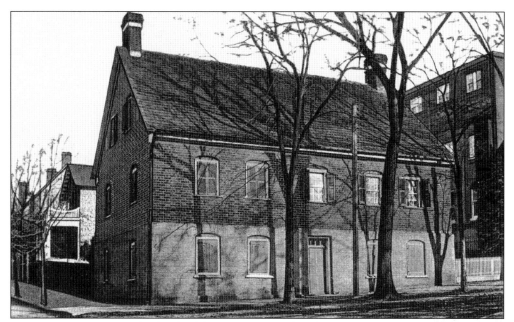

THE BOYS' SCHOOL. The first building erected in Salem by Johann Krause was constructed in 1794 on the corner of Main and Academy Streets. The building served as a school for boys until a new facility was constructed in 1896 at Church and Bank Streets. The Wachovia Historical Society moved into the vacated Boys' School in 1897, establishing the Wachovia Museum for the display and storage of Moravian artifacts.

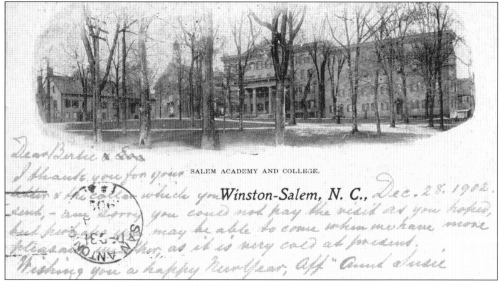

SALEM ACADEMY AND COLLEGE.

Winston-Salem, N. C., Dec. 28. 1902.

SALEM ACADEMY AND COLLEGE. This 1902 postcard was mailed to San Antonio, Texas, in the 100th anniversary year of the Salem Female Academy. The centennial was celebrated on commencement day with the cornerstone laying for Memorial Hall. On the evening of the commencement sermon, the Electric Company illuminated the word "Welcome," and the years "1802" and "1902" for the enjoyment of the outdoor service attendees. (Courtesy of Evelyn Shaw Styron.)

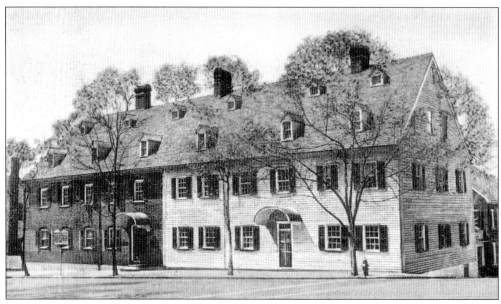

THE SINGLE BROTHERS' HOUSE. At age 14, Salem boys left their parents' home to live in the Single Brothers' House and learn a trade for their life's work. The single brothers operated the craft shops, as well as the distillery, brewery, and slaughterhouse. The half-timbered and brick building was completed in 1769 across from Salem Square. A log workshop for their trades was built in 1771 behind the house.

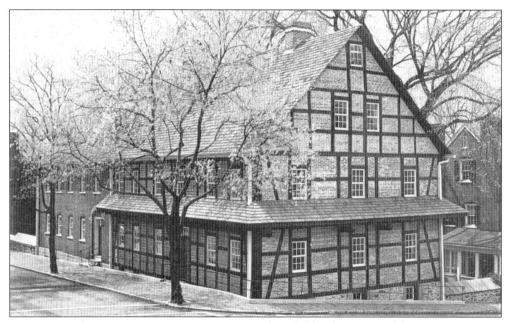

THE SINGLE BROTHERS' HOUSE, RESTORED. The solid brick portion of the Brothers' House was built in 1786, providing more room for their crafts. Economic problems forced the Brothers' House to close in 1823. The building was used as a school room and as a residence for Moravian women in 1910, when the Single Sisters' House was needed by Salem College. Today, the Brothers' House is restored to its 1769 and 1786 appearance.

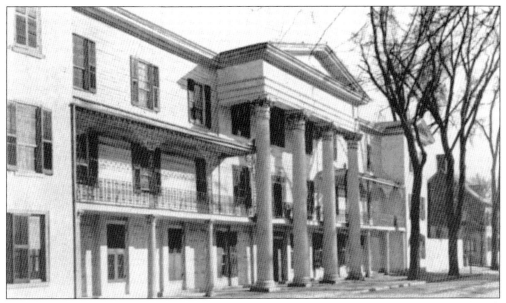

THE BELO HOME. Johann Friedrich Belo, a cabinetmaker, bought the house at Main and Bank Streets in 1808. His merchant son, Edward, bought the house in 1837 and converted the building to a dry goods store in 1840. A few years later, Edward bought an adjoining house and demolished both it and his house. In 1849 he built the first stage of the existing house, adding the rest in 1860.

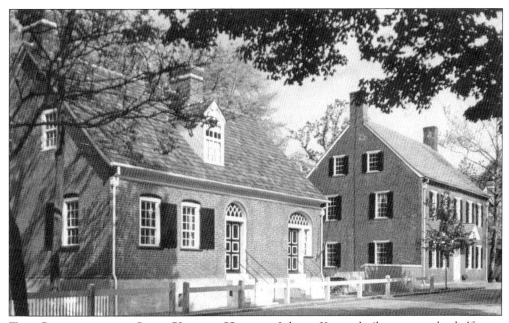

THE CHRISTOPH AND JOHN VOGLER HOUSES. Johann Krause built a one-and-a-half story house and shop for gunsmith Christoph Vogler in 1797. Three years later, Vogler moved to another part of town, and the house changed hands several times thereafter. John Vogler, Christoph's nephew and apprentice, built his house next door in 1819. He later became a silversmith and clock repair craftsman and made jewelry and silhouettes.

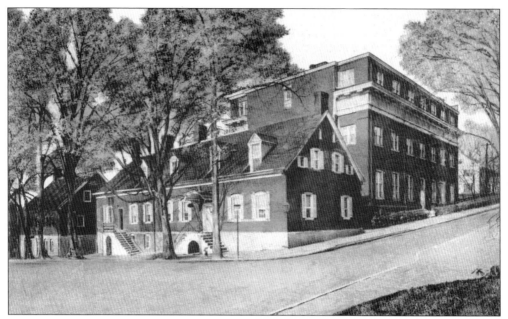

THE INSPECTORS' HOUSE AND MEMORIAL HALL. The home for the inspector, or headmaster, of the Girls' Boarding School was built in 1810. Located on the corner of Academy and Church Streets, the house was later used for Salem College and Academy administrative offices. Behind the inspectors' house was Memorial Hall, started in 1902 to commemorate the centennial of the college and academy. The building opened in 1907 and was demolished about 1965.

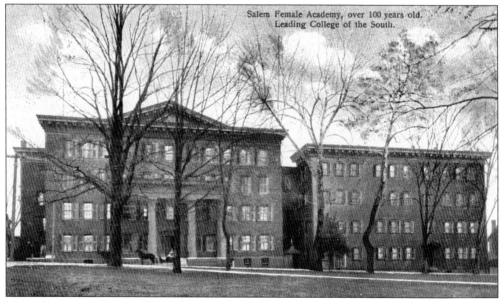

MAIN HALL AND SOUTH HALL. "Remember well and don't forget, you have a friend in Salem yet." This sentiment was written in 1907 to a woman in Winston-Salem from her correspondent, identified only by initials. The building on the right is South Hall, constructed in 1805 as the first structure built for the Girls' Boarding School. In 1854 the congregation house was removed and Main Hall was built in 1856.

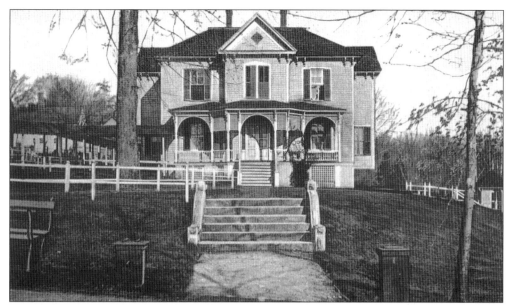

ANNEX HALL AND MEMORIAL STEPS. As the school continued to grow with more girls attending, additional buildings were needed to accommodate the students. Annex Hall was built in 1888 and housed the ninth and tenth room companies. Salem Female Academy experienced a building boom during this time, as Park Hall (1890) and Society Hall (1892) were added to the list of buildings. Park Hall was previously the church parsonage.

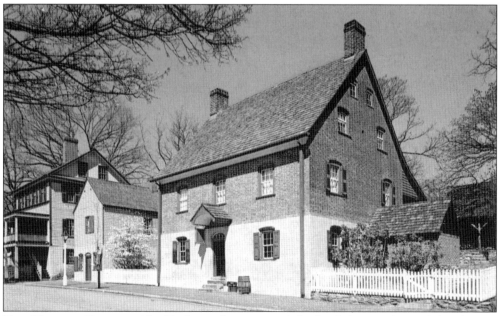

THE WINKLER BAKERY. The Single Brothers operated the first bakery in the workshop behind their house. In 1800 the shop on Main Street was built for Thomas Butner, the new master baker. The business was taken over by Christian Winkler in 1807 and was operated by the Winkler family until the late 1920s. Today, breads, cookies, and sugar cake are made in the restored building, sending delicious fragrances throughout Old Salem.

THE MIKSCH TOBACCO SHOP. Matthew Miksch built his one-story log house on South Main Street in 1771. The house consisted of two rooms, with a central chimney and small entrance foyer. Brother Miksch bought tobacco from area farmers and transformed it into twists for smoking and chewing. About 1782, he built a log manufactory behind the house for his tobacco operation and for the other goods he stocked in his store.

THE EMMA ORMSBY GRIFFITH MEMORIAL GARDEN. *Winston-Salem Journal* photographer Frank Jones took this image to accompany a newspaper article about the garden in 1964. The black-and-white image was also printed as a postcard to further publicize the restored garden behind the Miksch Tobacco Shop in Old Salem. The garden was named for Mrs. Griffith, a well-known flower arranger and a leader in garden club activities.

Two
PUBLIC BUILDINGS

Named for Col. Joseph Winston, a Revolutionary War hero and North Carolina legislator, Winston was an early leader in several industries, including tobacco, textiles, and banking. Winston's reputation as a tobacco town grew as it became the place to bring tobacco to market and as factories were built to process the tobacco. The influx of farmers prompted a need for basic services, such as livery stables, hotels, restaurants, groceries, hardware stores, clothing stores, and banks. Available jobs, land, and services combined to make Winston attractive to new arrivals and contributed to its growth.

Construction of the railroads benefited the city as a whole and contributed to the growth of Winston-Salem as a major industrial city in North Carolina. The government and public buildings reflected the "big city" attitude and were often financed by the drive and benevolence of the city's industrialists.

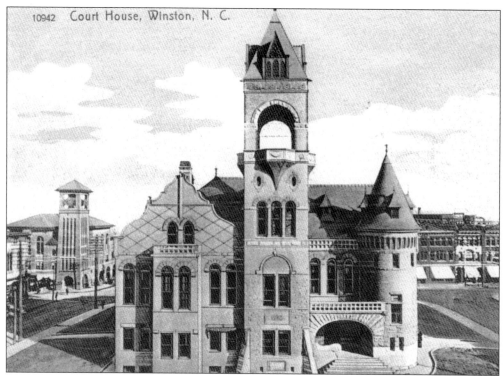

COURTHOUSE SQUARE. The first Forsyth County Courthouse was opened December 16, 1850, on a square surrounded by Fourth, Main, Third, and Liberty Streets. In addition to the courthouse, the square contained a fountain, walks, trees, wall, and a few benches. The second Forsyth County Courthouse opened January 1, 1897. This postcard view shows the second courthouse, with Town Hall at the back left. (Courtesy of Clarke and Della Stephens.)

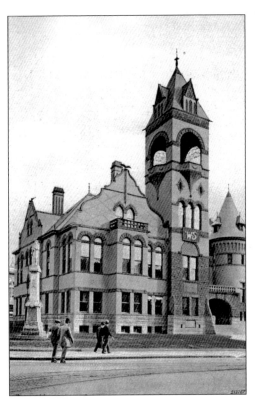

THE SECOND FORSYTH COUNTY COURTHOUSE. Frank Milburn designed a new courthouse on the original courthouse site. The building took 10 months to construct and was made of granite, buff brick, and brownstone. When it opened in January 1897, the courthouse gave Winston a big town look and continued to be the center of town activities. Band concerts, parades, and other celebrations took place around Courthouse Square. (Courtesy of Wayne and Louise Biby.)

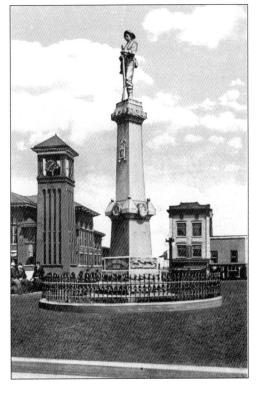

THE CONFEDERATE MONUMENT ON COURTHOUSE SQUARE. On the rainy morning of October 3, 1905, the James B. Gordon Chapter of the Daughters of the Confederacy unveiled the monument they had planned and financed. Over 600 veterans attended the ceremonies at the courthouse, presided over by Dr. H.T. Bahnson, also a veteran. The parade planned for the occasion was cancelled because of the weather. (Courtesy of Clarke and Della Stephens.)

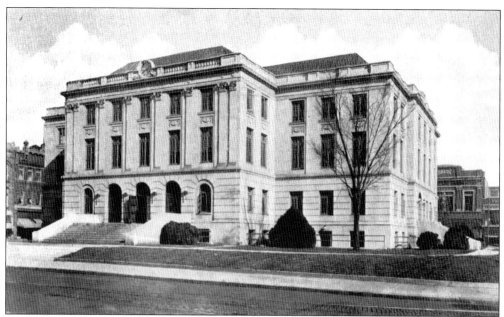

THE THIRD FORSYTH COUNTY COURTHOUSE. Crowded courthouse conditions forced a search for more space. In 1926 the building was extensively renovated, adding 25 feet to the Main and Liberty Street sides, changing the main entrance from Liberty to Main Street, removing the top portion of the tower, and making exterior changes. Two courtrooms were added to the second floor, and clock faces were added to the four sides of the building.

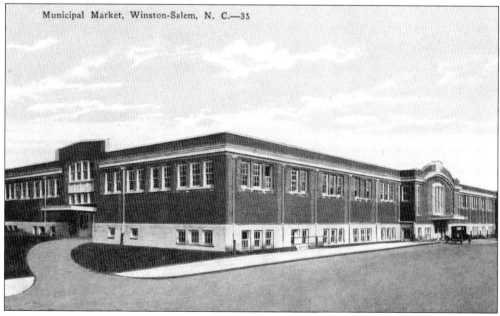

Municipal Market, Winston-Salem, N. C.—35

THE CITY MARKET. In the late 1880s farmers brought their produce to town and set up stands along the city streets. The stands began to block walkways, so the city established market space in the town hall. A new city hall was built and plans began for a new city market on the corner of Cherry and Sixth Streets. The new market opened July 4, 1925, and served the city until 1969.

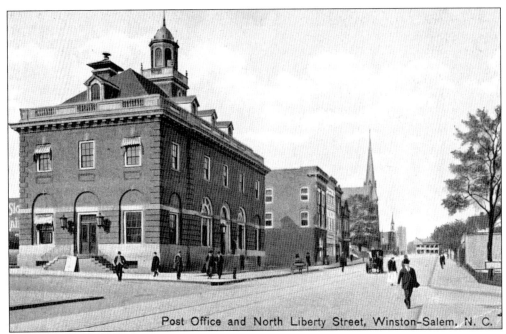

Post Office and North Liberty Street, Winston-Salem, N. C.

THE POST OFFICE, 1906. Harmon Miller built one of the first stores in Winston. It also housed Winston's first post office. John P. Vest, a store clerk, was the first postmaster. On July 1, 1899, the post offices of Winston and Salem were consolidated, adding the hyphen to their names. In 1906 the small post office shown on this postcard was built on the corner of Fifth and Liberty Streets.

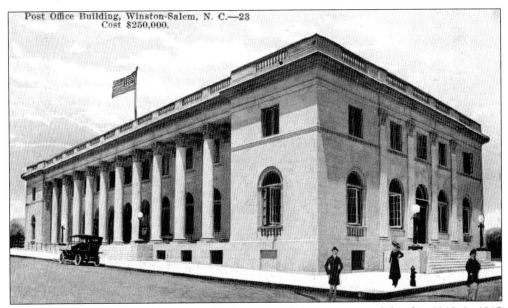

Post Office Building, Winston-Salem, N. C.—23
Cost $250,000.

THE POST OFFICE, 1915. The towns of Winston and Salem were consolidated in 1913. In 1915 a new post office was built from Liberty to Trade, along Fifth Street. The building was expanded in 1938, which doubled the floor space, adding 13,000 square feet to the back of the building. This facility also housed offices of the United States Deputy Marshall, District Attorney, Federal Prohibitions, and Navy Recruiting.

WINSTON TOWN HALL. As Winston grew, a town hall was planned to provide offices for town officials and other government services. The new town hall opened in 1893 on the corner of Fourth and Main Streets. In addition to town offices, the building also accommodated the armory, city market, fire department, and telephone exchange. The Seth Thomas clock in the tower kept townspeople on schedule. When Town Hall was demolished about 1927, the clock faces were purchased by Calvary Moravian Church and used in their church steeple.

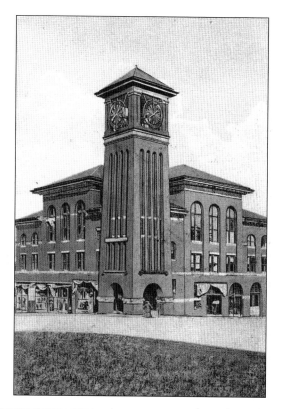

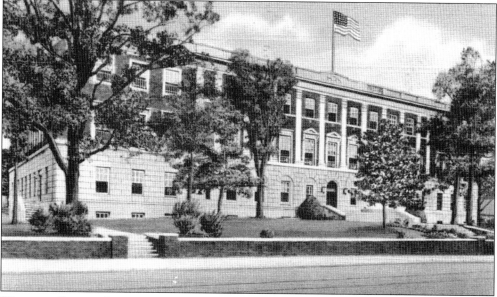

WINSTON-SALEM CITY HALL. Winston-Salem outgrew the town hall that once seemed so large. Judge D.H. Starbuck lived in a grand house, surrounded by trees, near the corner of Main and First Streets. After his death, the lot was sold to the city for a new city hall. Designed by Northup and O'Brien, the new city hall opened in 1926. The building was renovated in 1982 and again in 2003.

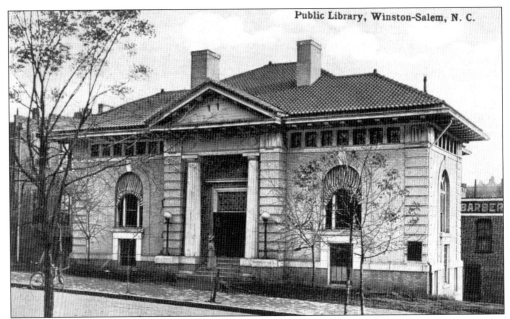

THE CARNEGIE LIBRARY. On February 14, 1906, the Carnegie Library was opened to the public at the corner of Cherry and Third Streets. The excellent library of the West End School was transferred to the new facility. For the next 47 years, this library served the children and adults of Winston-Salem. In preparation for the new library, it closed on March 7, 1953. Today, Our Lady of Fatima Catholic Chapel occupies this building.

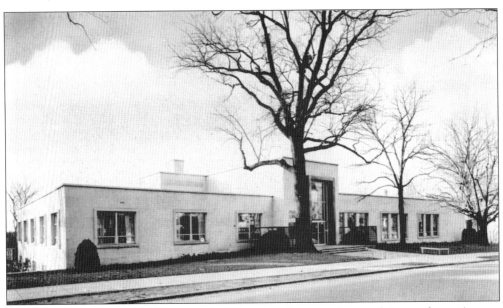

THE WEST FIFTH STREET LIBRARY. As Winston-Salem grew in population and prominence, the need for a larger library became critical. In December 1948, Dick Reynolds gave the city the property formerly occupied by the R.J. Reynolds home at Fifth and Spring Streets for a new library. Thanks to the money-raising efforts of Ralph Hanes, the groundbreaking took place on December 28, 1951, and the new library was dedicated March 26, 1953.

THE CHERRY STREET YMCA. This is one of several postcard views of the YMCA on the corner of Cherry and Fourth Streets. Some show the side view of the building. Others extend the view down Cherry Street to include the City High School next door and the First Presbyterian Church. The local YMCA was organized in 1888 and met in different locations until the construction of this $50,000 building in 1908.

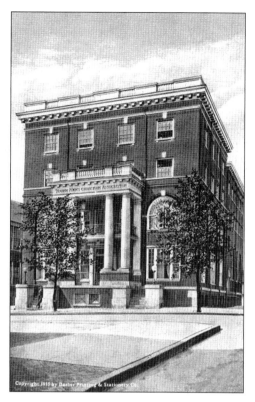

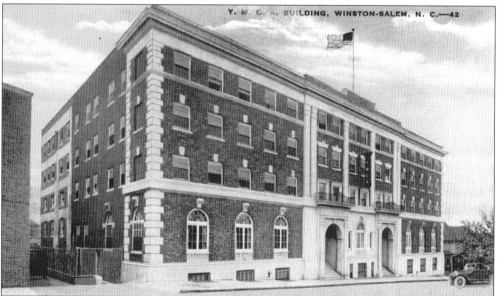

THE SPRUCE STREET YMCA. The new YMCA formally opened February 19, 1928, at 315 North Spruce Street, in a five-story brick and concrete building. The facility featured squash and handball courts, two gymnasiums, a swimming pool, a banquet hall, men's dormitory rooms, and offices. The building was sold in 1971 and leased to the YMCA until the new Central YMCA was completed in 1976. The building houses condominiums today.

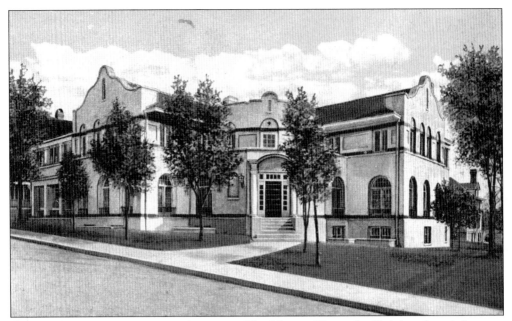

YWCA, First and Church Streets. The Young Women's Christian Association was organized locally on January 30, 1908, in First Presbyterian Church. Funds were raised for a permanent home and a building was completed in 1916 on the corner of First and Church Streets. The facility was formally opened on April 12, 1917, and featured a swimming pool and tennis courts. In 1942 a new YWCA was built on Glade Street.

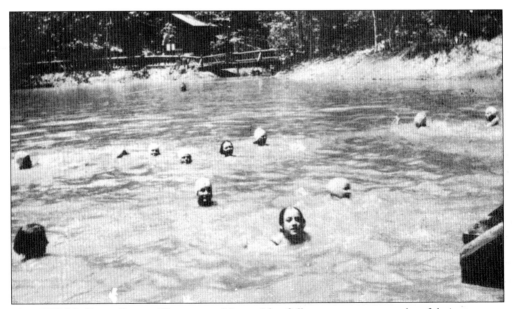

The YWCA Camp Betty Hastings. Many girls of all ages spent two weeks of their summers at the YWCA camp near Walkertown. Camp activities included arts and crafts, swimming, archery, drama, and overnight campouts. Each camp session included the famous "ship wreck party" and a mixer with the boy campers at YMCA Camp Hanes. The camp was named for Bettie Linville Hastings, former president of the Glade Street YWCA.

THE MASONIC TEMPLE. A charter was granted to Winston Lodge 167 in 1854, and Peter A. Wilson was the first master. Salem Lodge 289 was chartered in 1868. In 1907 the Masonic Temple was built on the corner of Fourth and Trade Streets, where the Piedmont Tobacco Warehouse once stood. The granite building was a combination office building and lodge hall. The building was demolished in 1927, replaced by Walgreen's Drugstore.

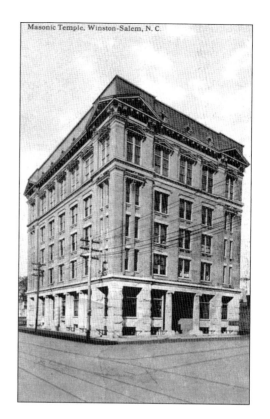

Masonic Temple, Winston-Salem, N. C.

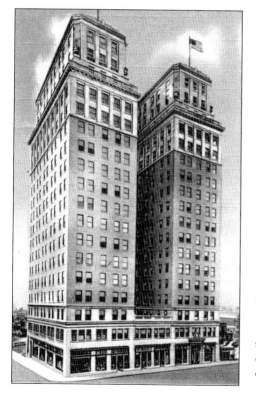

THE NISSEN BUILDING. For many years, the Nissen Wagon Works built sturdily constructed, high-wheeled wagons in Waughtown for traveling over rough terrain. William M. Nissen, former owner of the George E. Nissen Wagon Works, built the 18-story office building at Fourth and Cherry Streets in 1927. It has housed small businesses, such as barbershops and doctors, as well as a bank and a clothing store, during its long history.

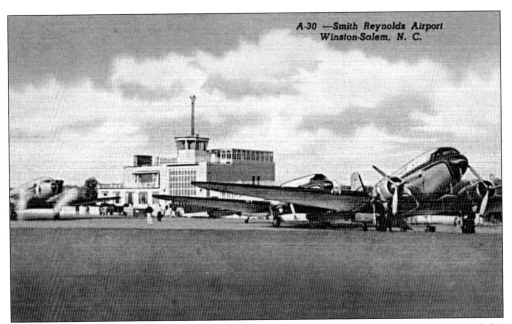

SMITH REYNOLDS AIRPORT. Winston-Salem outgrew its first airfield, Maynard Field, and the search began for a location that was close to downtown. Miller Municipal Airport's opening coincided with the arrival of Charles Lindbergh in 1927. A new terminal building was dedicated in 1942, named for Z. Smith Reynolds, and donated by his brother and sisters. Smith Reynolds, youngest son of R.J. Reynolds and a promising pilot, died as a young man.

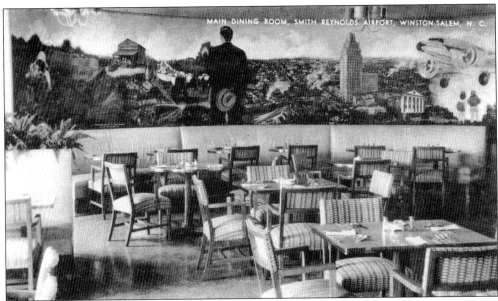

SMITH REYNOLDS AIRPORT DINING ROOM. Charles Augustus Jenkins was commissioned by R.J. Reynolds Jr. to paint a mural for the airport's dining room wall. The panorama depicts city buildings, businesses, industries, landmarks, aviation, and individuals from the city's history. An unidentified man stands with his back toward the room. Mr. Jenkins restored the mural in 1961, but he never revealed the man's identity. (Courtesy of Evelyn Shaw Styron.)

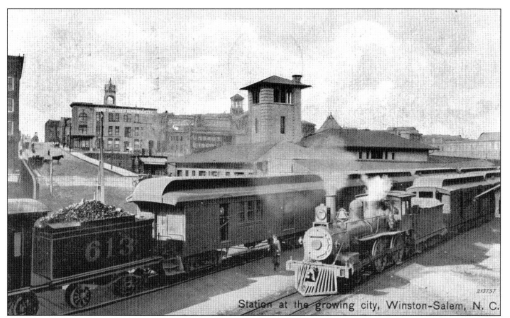

Station at the growing city, Winston-Salem, N. C.

FOUNDING THE SOUTHERN PASSENGER STATION. The railroad line from Greensboro to Winston-Salem was completed in 1873. The town needed a train station, and an effort was headed by the Young Men's Business Association. Mrs. George Norfleet, whose father headed the law department of Southern Railway Company, laid the first brick for the depot on October 21, 1903. Frank Milburn designed the building, which opened in May 1904.

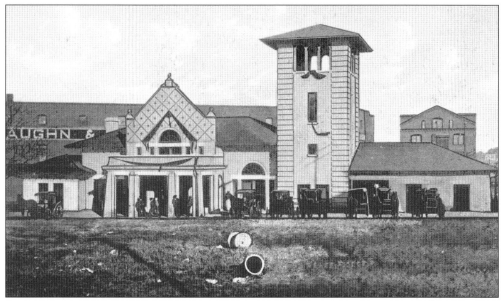

THE SOUTHERN PASSENGER STATION. The new passenger station was built on a pie-slice piece of land surrounded by businesses on Chestnut Street, between Third and Fourth Streets. This 1909 postcard shows the ornate facade of the station and the similarities to the second Forsyth County Courthouse, also designed by Frank Milburn. The station served Winston-Salem until 1926, when a new union station was built. (Courtesy of Clarke and Della Stephens.)

33

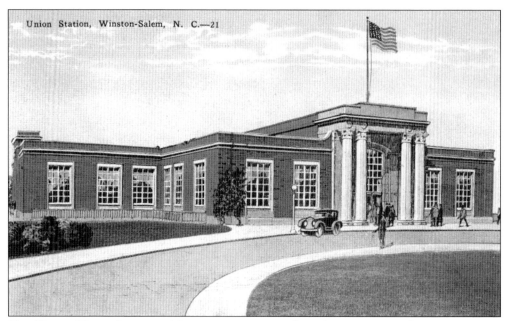

THE UNION TRAIN STATION. The new station opened April 15, 1926, on Claremont Avenue. Built on three levels, the station featured a circular front drive, waiting rooms with marble floors and comfortable seating, a baggage check service, a restaurant, modern restrooms, and a travelers' aid shop with newsstand items. The station operated until July 9, 1970. After extensive renovations, it reopened as Davis Garage. (Courtesy of Julian Harris.)

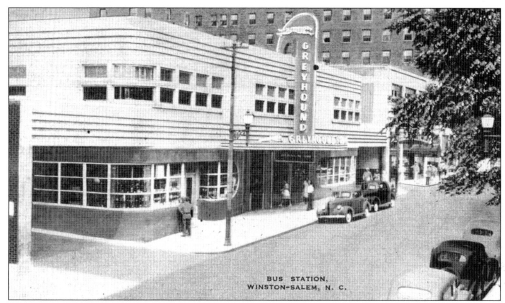

BUS STATION,
WINSTON-SALEM, N. C.

THE UNION BUS STATION. The city's first bus station was built beside the Zinzendorf Hotel on Main Street. The station had limited seating and no expansion space. A new station was built on the block bordered by Cherry and Marshall Streets, beside the K&W Cafeteria, near the Robert E. Lee Hotel. Another bus station was built near this location in 1942. The large, modern station is shown on this postcard.

Three
DOWNTOWN VIEWS

Forsyth County was established in 1849, and Salem sold 51.25 acres to the county commissioners for the new county seat. The acreage was divided into 72 lots, with 1 lot designated for the courthouse and the others sold at public auction. The courthouse was two stories tall, with four pillars supporting a portico, and faced south towards Salem. It opened in December 1850.

The area surrounding Courthouse Square was a prime location for a home or a business, although the businesses eventually prevailed. Courthouse Square bustled with activity, even when courts were not in session. It was a popular meeting place as residents went about their daily activities. Eventually, the town stretched its boundaries in all directions, with businesses occupying more of the downtown area and residents establishing new neighborhoods beyond the business district.

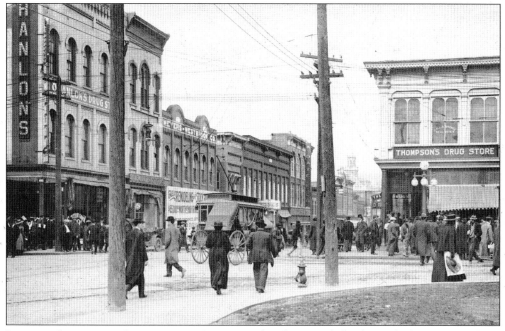

LIBERTY STREET AT COURTHOUSE SQUARE. The photograph for this real-photo postcard was made at the intersection of Liberty and Fourth Streets. The sign on the Meyers-Westbrook Company Department Store (second left) announces a remodeling sale, which began in January 1913. Thompson's Drug Store (right), founded by Dr. V.O. Thompson, was the oldest drugstore in town, moving to this location after the store on Liberty Street burned in 1880.

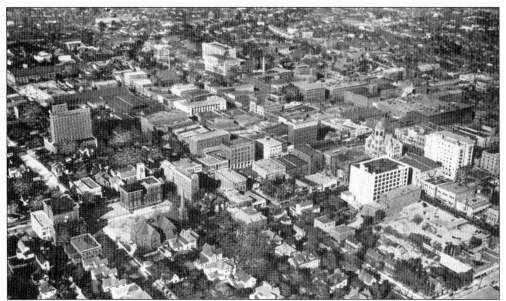

A Downtown Aerial, 1924. This aerial was taken right before Winston-Salem's downtown building boom. The second Forsyth County Courthouse is recognizable near the right of the photo, blocking the view of Town Hall. There are still many houses among the trees near the entire bottom section of the postcard. A vacant lot is between First Presbyterian Church and the YMCA on Cherry Street, where the City High School burned in 1923.

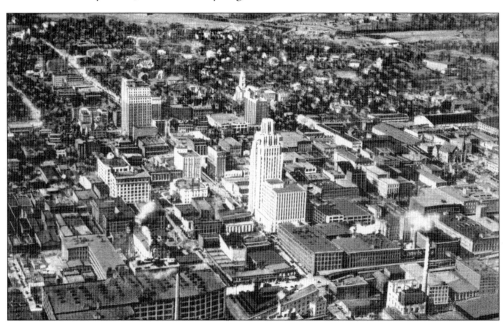

A Downtown Aerial, After 1929. The 22-story Reynolds Building was constructed in 1929. From that time on, dating and identifying downtown aerial photographs became easier when positions relative to the Reynolds Building could be determined. The bottom part of this postcard shows many of the tobacco factories located on Church and Chestnut Streets and stretching northward from Second to Fifth Streets.

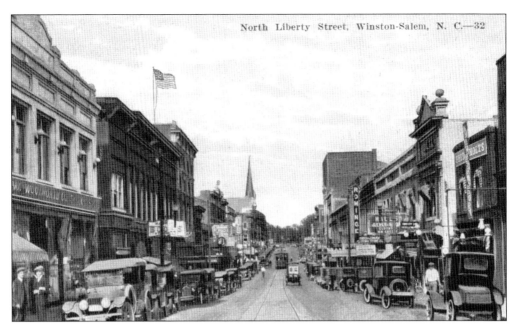

LIBERTY STREET LOOKING NORTH. The 400 block of Liberty Street contained a mixture of retail businesses, theatres, services, and offices when this postcard was made about 1923. F.W. Woolworth and Watkins Book Store were located on the left side of the street. Fred Holt's Barber Shop, Rominger's Furniture Store, and the Ideal and Broadway Theatres were located on the right side of the street. (Courtesy of Sarah Murphy McFarland.)

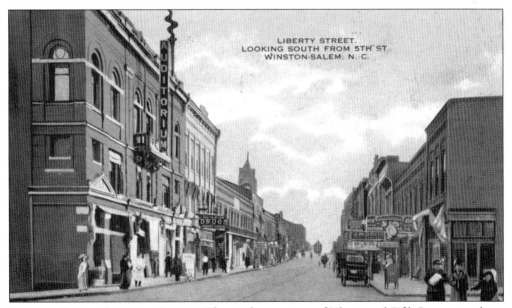

LIBERTY STREET LOOKING SOUTH. The southeast corner of Liberty and Fifth Streets was about to undergo a change when this postcard was mailed in February 1916. The change occurred on April 27, 1916, when the Elks Auditorium (left) and the Neil Hotel burned. The auditorium was replaced by the Auditorium Theatre, which became the State Theatre and was later changed to State Furniture. (Courtesy of Clarke and Della Stephens.)

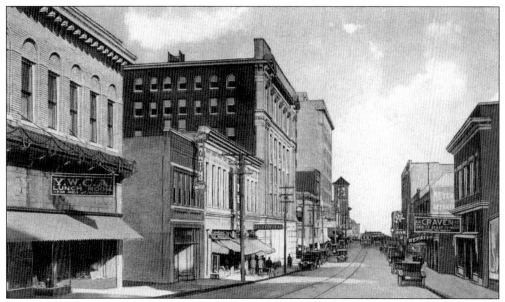

LOOKING EAST ON FOURTH STREET. This mid–1920s view of Fourth Street was taken near the intersection with Cherry Street. The landscape changed drastically about 1927 when the Masonic Temple and the Town Hall were demolished. The YWCA Lunch Room sign at left advertised meals for men and women. D.G. Craven and Company at right was a ladies' ready-to-wear store with a beauty parlor. (Courtesy of Stephen E. Massengill.)

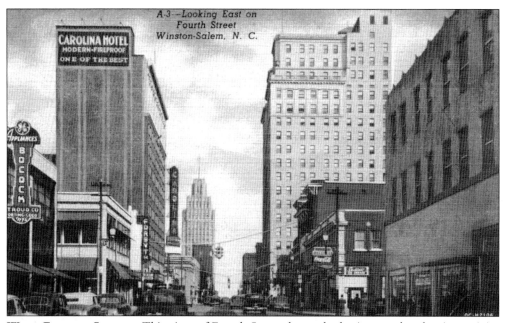

WEST FOURTH STREET. This view of Fourth Street shows the business and pedestrian activity in this area. At the left is Bocock Stroud Company, a store specializing in sporting goods, toys, appliances, and cameras and supplies, among other items. The Forsyth Theatre is down the street, near the Carolina Hotel. The Reynolds, Nissen, and Loewy Buildings are near the center and at right. Thalhimer's Department Store later occupied the Loewy Building.

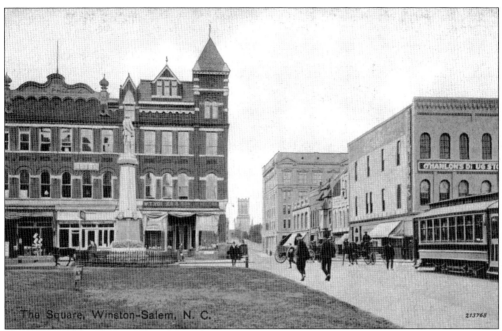

FOURTH STREET, LOOKING WEST. These two postcards show how this street and the city changed over a period of about 30 years. The top postcard, dated 1912, shows the Phoenix Hotel, St. Paul's Episcopal Church far in the distance, the Masonic Temple, the three-story O'Hanlon's Drug Store, and a streetcar. The landscape changed when O'Hanlon's burned in March 1913. In the bottom postcard, made after 1936, the new courthouse occupies more of Courthouse Square. Many automobiles fill the streets, and the Pepper Building has replaced the Phoenix Hotel. The Carolina Hotel is in the far distance, Walgreen's Drug Store has replaced the Masonic Temple, and the eight-story O'Hanlon Building towers over the corner of Fourth and Liberty. Buses have replaced the streetcars, but the safety zone beside the bus is still in place and there are no electric traffic signals.

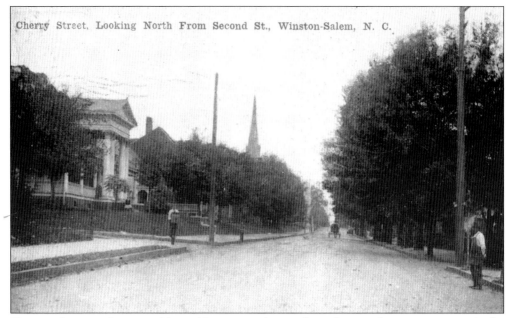

NORTH CHERRY STREET. City residents moved away from the courthouse square area in the mid-to-late 1800s and established new neighborhoods, building grand homes on Cherry Street. Some of the early residents were James A. Gray, A.H. Galloway, G.W. Coan, P.H. Hanes, and John Wesley Hanes. Cherry Street became the city's first "millionaires' row," which extended to West Fifth Street. (Courtesy of Wayne and Louise Biby.)

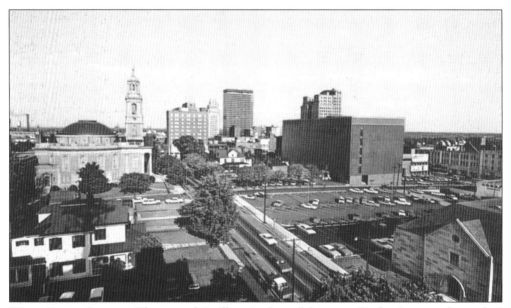

WEST FIFTH STREET. The second "millionaires' row" began at Poplar Street and stretched westward along Fifth Street to Brookstown Avenue. Some of the Cherry Street residents built homes in the new neighborhood, joined by others who ventured out of the downtown area. A.P. Gorrell built the first house in 1877, near the corner of Fifth and Poplar. Businesses, churches, and parking lots eventually replaced the grand Fifth Street homes.

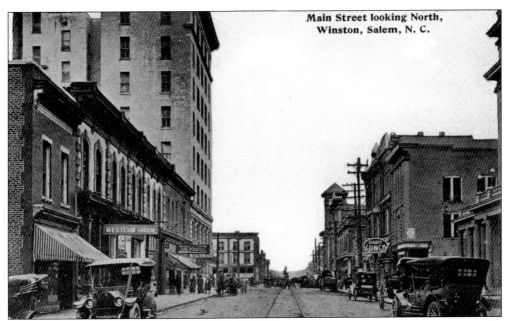

MAIN STREET LOOKING NORTH. The Zinzendorf Hotel can barely be seen at the right in this view of the 200 block of North Main Street. Western Union Telegraph Company is conveniently located across the street. This postcard was mailed in January 1914, when the tall Wachovia Bank Building was just three years old. The nearby Vogue, in business since 1896, specialized in men's wear "tailored to your measure." (Courtesy of Julian Harris.)

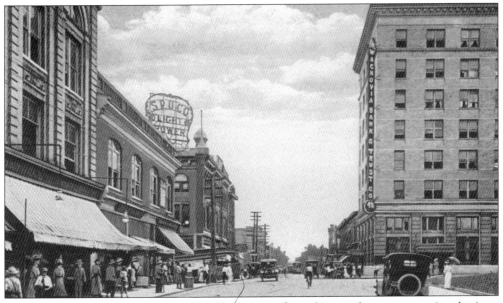

MAIN STREET LOOKING SOUTH. The block across from the courthouse was a prime business location. The 300 block of Main Street in 1916 featured many businesses, including the S&H Kress Company, at left. The sign on top of the Joe Jacobs block stands for Southern Public Utilities Company (SPUCO). This company ran the streetcars and provided lighting and power. Their clubrooms were located in the Joe Jacobs building.

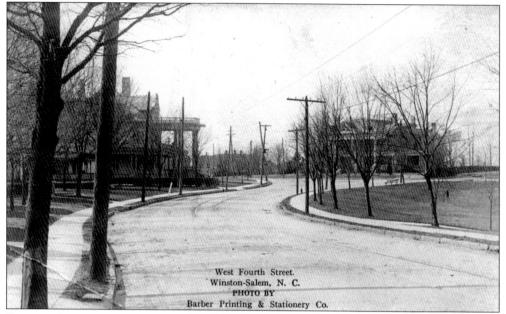

FOURTH STREET LOOKING WEST. Barber Printing & Stationery Company printed a series of real-photo postcards about 1915 that featured churches, public buildings, streets, and other interesting subjects in Winston-Salem. In this 1920 postcard, Grace Park is at the right, with two large homes in view. The left house belonged to J. Cicero Tise, and the right house belonged to Mrs. John Wesley Hanes. (Courtesy of Evelyn Shaw Styron.)

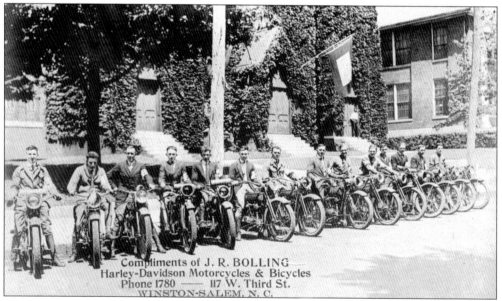

MOTORCYCLES ON NORTH CHERRY STREET. James R. Bolling was an agent for bicycles and Harley-Davidson motorcycles in his shop at 117 West Third Street. Bolling (left) moved his business to Marshall Street in the late 1920s. He was making a transcontinental motorcycle trip to California in 1930 when he crashed and died in Arkansas. His wife, and then his son, continued with the business into the 1950s. (Courtesy of Julian Harris.)

Four
TOBACCO INDUSTRY

It was once difficult to find a Forsyth County resident who did not have some family connection to the tobacco industry, through the growing, marketing, manufacturing, or selling of tobacco and tobacco products.

The first tobacco manufacturer in Winston was Major Hamilton Scales, beginning work in 1870 in a Liberty Street carriage house. P.H. Hanes & Company, founded in 1873 as the fourth tobacco company in town, was considered to be Winston's largest tobacco manufactory in 1888.

Richard Joshua Reynolds began his business in 1875. By 1888 he employed 250 to 300 hands in his Chestnut Street factory. Some of his leading brands at that time were "National," "R.J.R.," and "World's Choice." Reynolds later purchased P.H. Hanes' tobacco operations and continued to grow until the company became the country's tobacco leader.

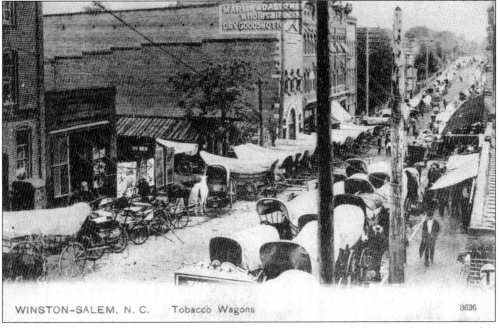

WINSTON-SALEM, N. C. Tobacco Wagons 3626

TOBACCO WAGONS. A familiar sight on Winston's streets, particularly around tobacco market time, was the tobacco wagon. A well-built and reliable wagon for transporting the tobacco leaf to market was necessary for the growth of the tobacco industry in Winston. George E. Nissen & Company and J.C. Spach Wagon Works manufactured wagons that were sold in North Carolina, South Carolina, and Virginia. (Courtesy of Clarke and Della Stephens.)

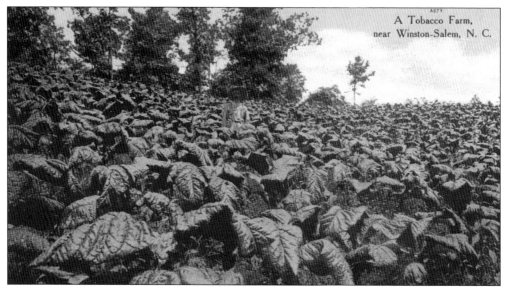

A TOBACCO FARM. When Moravians settled at Bethabara in 1753, a tobacco crop was included in their first harvest. The majority of North Carolinians engaged in some form of agriculture. This held true for Forsyth County residents. A large quantity of tobacco was grown in 1858. The "yellow-leaf" tobacco was considered superior even to that grown in Henry County, Virginia, thus increasing its popularity in Forsyth County.

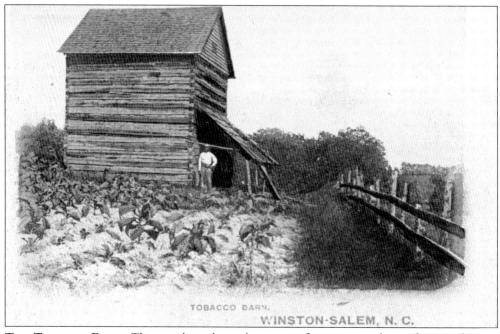

TOBACCO BARN.
WINSTON-SALEM, N. C.

THE TOBACCO BARN. The wooden tobacco barn was a fixture on a tobacco farm until it was replaced by metal bulk barns. The tobacco was strung onto sticks and hung in the barn for curing. The term "flue-cured tobacco" comes from curing tobacco with heat in pipes, called flues. When the curing was finished, the tobacco was graded, tied into hands, and carried to the tobacco warehouse. (Courtesy of Stephen E. Massengill.)

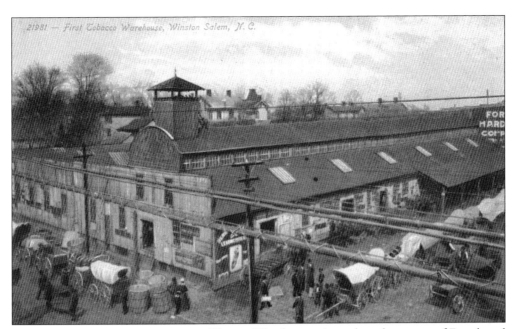

PIEDMONT TOBACCO WAREHOUSE. Planters Warehouse, situated on the corner of Fourth and Trade Streets, was purchased by M.W. Norfleet in 1875. He enlarged the building and changed the name to Piedmont. For many years, wagons loaded with tobacco lined the street, prompting the name change from Old Town to Trade Street. Boarding houses, hardware stores, stables, lunchrooms, and other Trade Street businesses profited from a good tobacco-selling season.

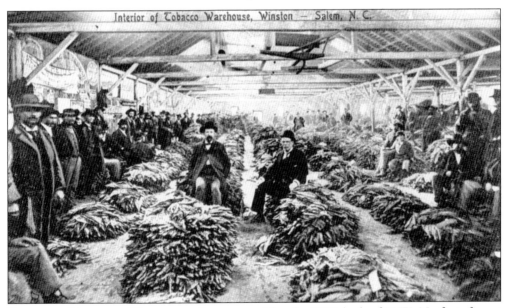

PIEDMONT TOBACCO WAREHOUSE INTERIOR. After the 1889 death of M.W. Norfleet, former partner James S. Scales and James K. Norfleet operated the business. The key to a profitable tobacco warehouse was to hire a talented auctioneer. Col. Garland Webb auctioneered for the Farmers' Warehouse before beginning his longtime employment with Piedmont. Replaced in 1907 by the Masonic Temple, a new Piedmont Warehouse was built further north on Trade Street.

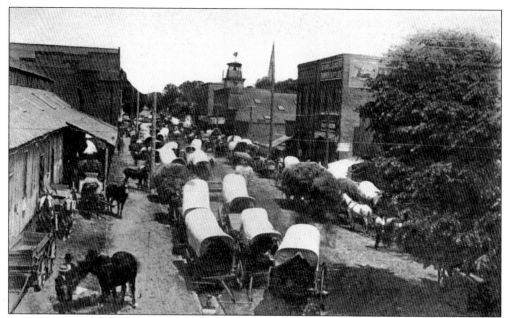

NORTH TRADE STREET. The two postcards on this page show North Trade Street at different times. Tobacco wagons, people, horses, and trees are prominent in the area near the Piedmont Tobacco Warehouse in the top postcard. The general merchandise store of H.D. Poindexter is at the right. Henry Dalton Poindexter conducted his business at this location for many years. His store is also shown in the bottom postcard, printed after 1907. In his two-story store he carried dry goods, notions, garments, groceries, seed, fertilizer, and sundry articles. When farmers were paid for their tobacco, they bought food, clothing, and other provisions in town, so stores located near the warehouses were in a prime location. The stone building at the left in the bottom postcard is the Masonic Temple, built in 1907. (Courtesy of Stephen E. Massengill.)

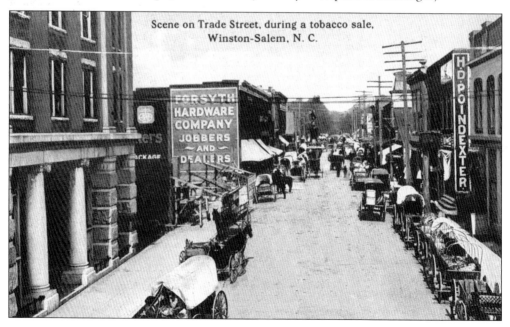

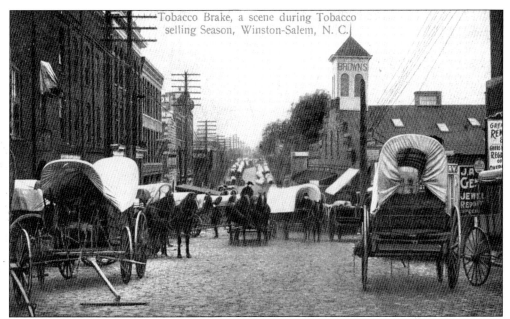

BROWN'S TOBACCO WAREHOUSE, MAIN STREET. Tobacco-laden wagons line North Main Street in this 1907 postcard. Maj. T.J. Brown began selling tobacco from a remodeled stable on Liberty Street in 1872, marking the first sale of leaf tobacco in Winston. Later that year, he built a warehouse on Church Street and, in 1884, built the Brown's Tobacco Warehouse on North Main Street, shown at the right in the postcard.

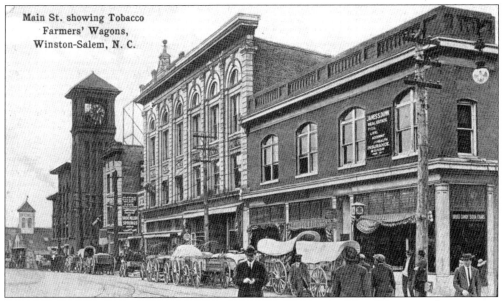

NORTH MAIN STREET. Wagons carrying tobacco line the 300 block of Main Street in 1917, with Brown's Warehouse at the far left. At one time, Maj. T.J. Brown was in the tobacco business with P.H. Hanes, but Brown sold his interest before the Hanes brothers sold their company to R.J. Reynolds. Streets around the warehouses teemed with farmers and wagons when "brakes," or auctions, were in session.

47

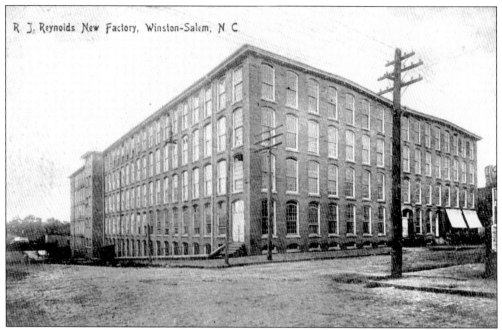

R.J. REYNOLDS TOBACCO COMPANY FACTORY #1 AT 8. Excavations began in 1899 for a new factory at the corner of Fifth and Church Streets. Over 100 carloads of rock filled the site to make a sturdy foundation. Known as the "flat-top" building, the factory contained double the floor space of #256 and featured electrical equipment and larger company office space. (Courtesy of Clarke and Della Stephens.)

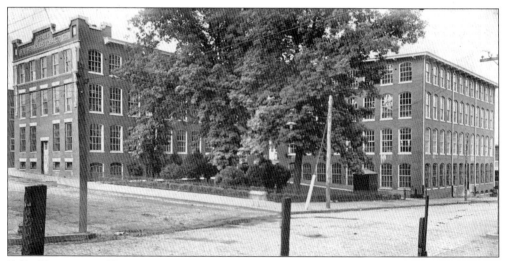

R.J. REYNOLDS TOBACCO COMPANY OFFICE BUILDING. Company offices originally occupied a corner in the first red factory. They then moved to factory #256 in 1892 and to factory #8 in 1900. The factories needed space for manufacturing, so the offices continually sought space in the newest building. With an office force of 200 employees, Reynolds built the #38 building in 1911 on the corner of Main and Fifth Streets.

R.J. REYNOLDS TOBACCO COMPANY OFFICE BUILDING. When the four-story building was first occupied in 1911, the first floor was devoted to offices. Thirteen private offices housed company officials. They were furnished with mahogany furniture and located in the wing facing Main Street. The sales and accounting departments were located in the opposite wing. Special features included the "excellent lighting facilities" and large and plentiful windows for light and ventilation.

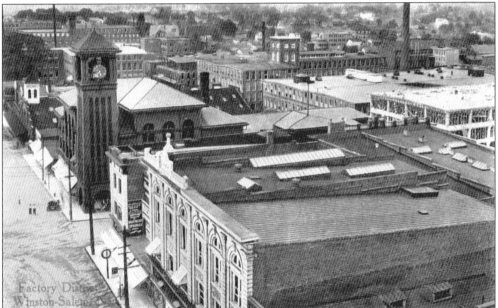

MAIN STREET AERIAL LOOKING NORTHEAST. This aerial shows Main at Fourth Street. The tall structure with the tower is Town Hall. Factories occupy much of the landscape on Church Street and beyond. The white structure on the right of the card is R.J. Reynolds factory #4, a concrete structure built by Reynolds after World War I and intended to be a lithographing plant. (Courtesy of Evelyn Shaw Styron.)

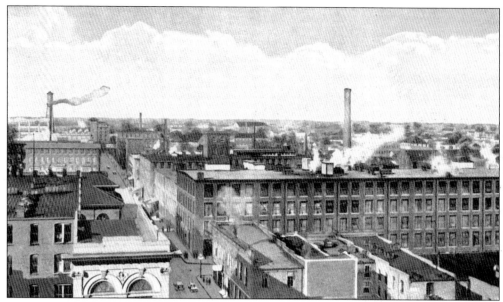

AN AERIAL OF THE MANUFACTURING DISTRICT. This aerial of North Church at East Fourth Street was taken about 1924. The factories near the center of the postcard are in the R.J. Reynolds #8 complex. The buildings in the right foreground comprise the block that was demolished for the Phillips Building. The left foreground building with the half-moon windows was the Jones Building, which burned in 1960. (Courtesy of Sherry Joines Wyatt.)

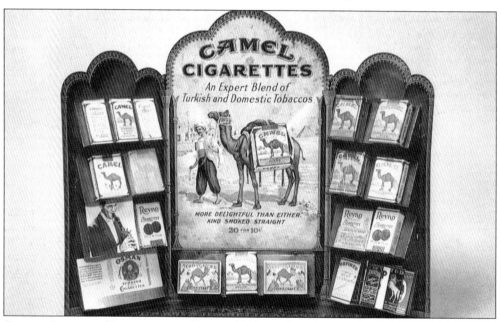

CAMEL COUNTER DISPLAY FROM EARLY 1900s. When the Whitaker Park plant opened in 1961, the plant tours showed the manufacturing operation and ended at an exhibit area where visitors could browse through tobacco memorabilia and advertising artifacts. This Camel counter display shows several early Reynolds brands. Refined, a smoking tobacco, was introduced in 1907. Camel, Red Kamel, Reyno, and Osman are cigarette brands, all introduced in 1913.

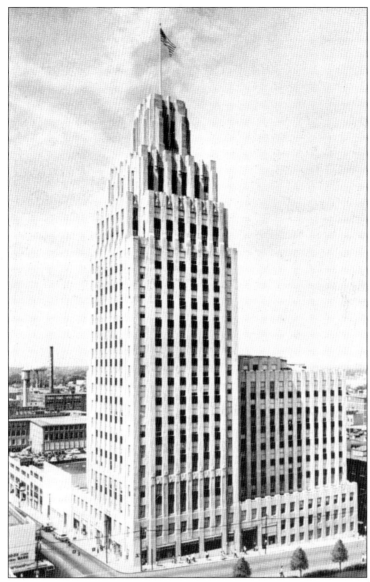

THE REYNOLDS BUILDING. From the revolving brass front door to the marble hallways to the top of the 65-foot flagpole, the Reynolds Building has a timeless presence and elegance in downtown Winston-Salem. Built on the site of Town Hall at the corner of Main and Fourth Streets, the 22-story Reynolds Building was occupied April 23, 1929. Shreve and Lamb of New York, who later designed the Empire State Building, were the architects. The National Association of Architects named the Reynolds Building its "Building of the Year" for 1929. In addition to the many R.J. Reynolds Tobacco Company office employees, the building has also housed insurance and brokerage firms, attorneys, architects, developers, rail line offices, a barber and shoe shine shop, optometrists, and Bobbitt's Pharmacy. Other public areas included the Reynolds Grill and Cafeteria, which became the Cavalier Grill and later became the Caravan Room. Dedicated in 1951, the smallest public room was the chapel, which measured 9 by 12 feet and was built with stained glass windows. The Reynolds Building is a popular subject for postcards and has been pictured in a variety of views.

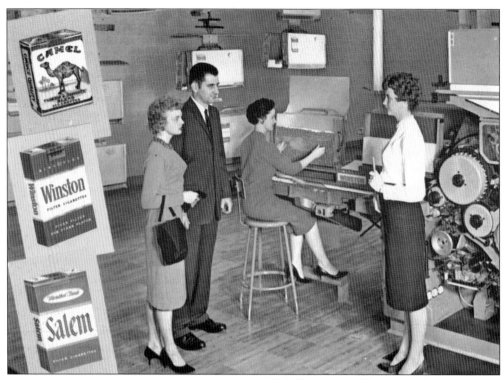

R.J. Reynolds Tobacco Company Tour. This guide shows visitors how filtered cigarettes are discharged on a conveyor belt, visually inspected, and lifted by hand into the metal tray. The tray, carrying approximately 4,000 cigarettes, is taken to a packing machine, where the cigarettes are fitted into packs of 20 and then loaded into cartons. The process in 1962 was much different from today's automated operations.

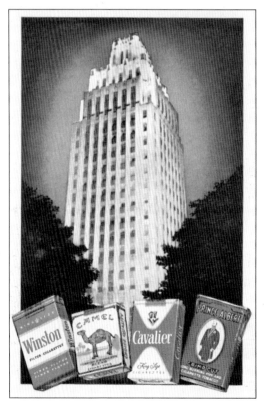

Reynolds Building and Tobacco Products. This is one of three postcards featuring the identical view of the Reynolds Building with tobacco products at the bottom of the card. One postcard shows two products, Camel and Prince Albert. Another card shows Cavalier, Camel, and Winston. This card shows Winston, Camel, Cavalier, and Prince Albert. The brands were introduced as follows: Prince Albert (1907), Camel (1913), Cavalier (1949), and Winston (1954).

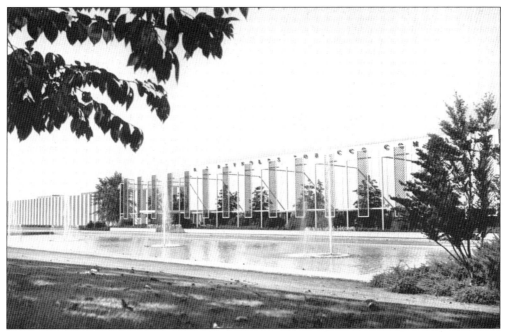

R.J. Reynolds Tobacco Company Whitaker Park Plant. Ground was broken for Whitaker Park Cigarette Plant in 1958, and the first shipment of Winston cigarettes left the plant on April 26, 1961. Named for John C. Whitaker, chairman of the R.J. Reynolds Tobacco Company Board of Directors from 1952 to 1959, the plant covers approximately 14 acres on Reynolds Boulevard. The Reynolds Engineering Department designed and constructed the entire building.

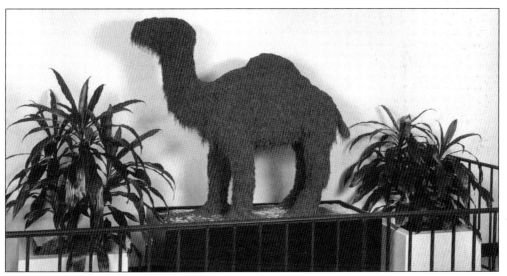

"Old Joe" Camel. Company tours were conducted in the downtown plants until Whitaker Park was built. "Old Joe," covered in fine tobacco strips, greeted visitors in the Whitaker Park lobby. "Old Joe" was the name given to the Barnum and Bailey Circus dromedary that posed for local photographer Andrew Farrell and later appeared on the Camel Cigarette label. Company tours were discontinued at Whitaker Park in 1998.

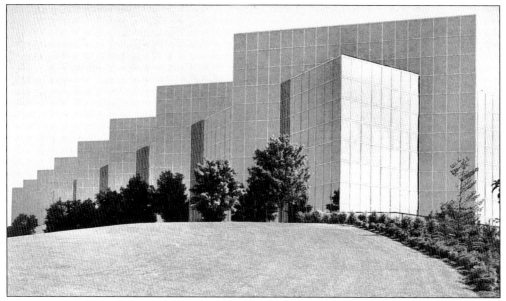

R.J. Reynolds Industries World Headquarters Building. North Carolina Gov. James B. Hunt was present on March 17, 1978, for the dedication of the five-story, $40 million headquarters building made of reflective glass. Operations for RJR's tobacco, energy, containerized shipping, foods, beverages, aluminum products, and packaging divisions were directed from this building atop Reynolds Boulevard hill. Modern furnishings, automated controls, and the North Carolina Art Collection enhanced its unique design.

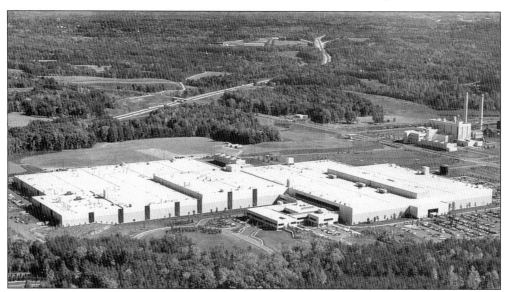

R.J. Reynolds Tobacco Company, Tobaccoville Manufacturing Center. The world's largest and most automated cigarette manufacturing plant was dedicated on September 19, 1986, in Tobaccoville. The plant has 2 million square feet of floor space under a 27-acre roof. Employees use three-wheeled bicycles to move quickly from one end of the factory to another. Automated guided vehicles transport pallets of cigarettes across the plant. (Courtesy of Clarke and Della Stephens.)

Five
BUSINESS AND INDUSTRY

While tobacco was the major industry in town, the city also enjoyed a wealth of enterprising individuals who established companies that made a place for themselves in the business annals of the city. Many of these companies that began in the early days of Winston-Salem's history still exist and continue to contribute to the city's economy. In addition to R.J. Reynolds Tobacco Company, some nationally recognized corporations were founded in Winston-Salem, including Piedmont Airlines, Krispy Kreme, Wachovia Bank, and Hanes Corporation (Sara Lee) to name a few.

The twists and turns of local businesses have given Winston-Salem a fascinating financial history. The endless list of businesses comprises the interesting and colorful history that once named Winston-Salem the "City of Industry."

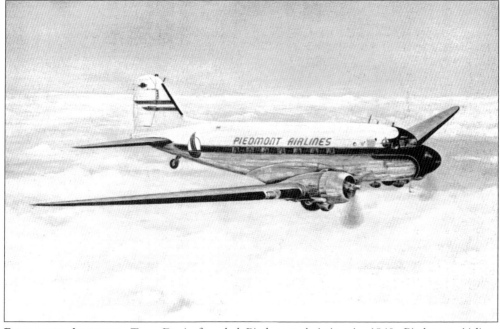

PIEDMONT AIRLINES. Tom Davis founded Piedmont Aviation in 1940. Piedmont Airlines launched its air service in February 1948 with a fleet of refurbished DC-3s. The airline industry was deregulated in 1978, and Piedmont became a public company. The airline operated from Smith Reynolds Airport until 1983. USAir Group purchased the company in 1987, and Piedmont's last flight was made in 1989. (Courtesy of Clarke and Della Stephens.)

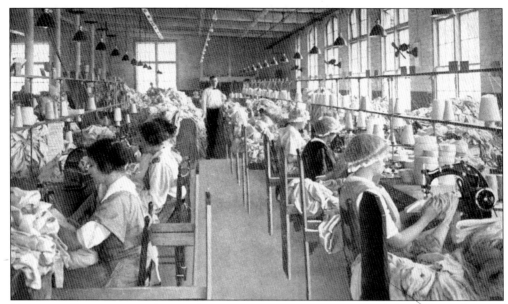

FINISHING DEPARTMENT, UNION SUITS. P.H. Hanes & Company sold their tobacco business in 1900 to R.J. Reynolds Tobacco Company. In 1901 P.H. Hanes Sr., with sons P.H. Hanes Jr. and W.M. Hanes, founded P.H. Hanes Knitting Company in an old tobacco factory at Church and Sixth Streets. In 1913 Hanes manufactured their first union suits. (Courtesy of Stephen E. Massengill.)

FOLDING AND BOXING SHIRTS, P.H. HANES KNITTING COMPANY. Hanes, as a brand name, was unknown until about 1913 because the goods were sold for private packaging. The company wanted an identity for their goods and began packaging and labeling their products as Hanes Underwear. In 1917 and 1918, during World War I, the federal government contracted with Hanes to make undershirts for the army. (Courtesy of Stephen E. Massengill.)

SUPERINTENDENT'S RESIDENCE AND MILL NO. 3, HANES, NORTH CAROLINA. Hanes Knitting Company was one of the first companies to manufacture knitted underwear in the South. In 1910 the company built their first spinning mill at Hanes (Stratford Road) and another cotton mill in 1917, providing a total of 27,000 spindles. The products from these mills were used to make their knit underwear. (Courtesy of Clarke and Della Stephens.)

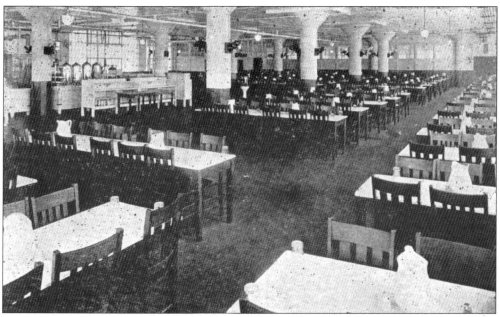

THE HANES KNITTING COMPANY CAFETERIA. Hundreds of Hanes employees ate lunch in the company cafeteria. In 1914 Hanes constructed a reinforced steel and concrete building on the corner of Main and Sixth Streets. The new building provided ample space, high ceilings, and satisfactory natural and artificial light. In 1920 the north building was erected and provided ample manufacturing space for years to come. (Courtesy of Clarke and Della Stephens.)

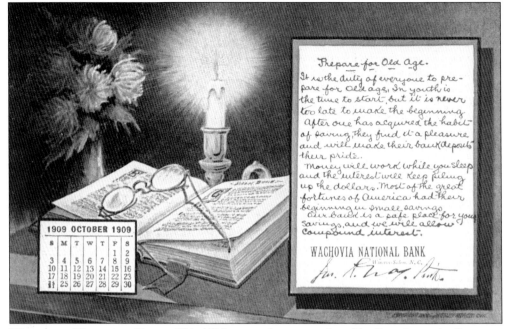

WACHOVIA NATIONAL BANK. This 1909 postcard message, signed by Pres. James A. Gray, admonished readers to "Prepare for Old Age." The advice is to begin saving in youth because "money will work while you sleep and the interest will keep piling up the dollars." The Wachovia National Bank opened for business in 1879 with a capital stock of $100,000.

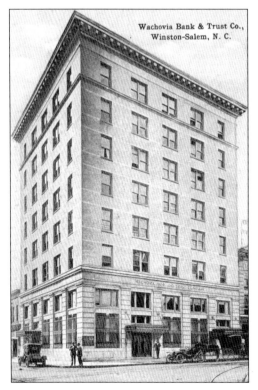

WACHOVIA BANK & TRUST COMPANY. This company was formed in 1911 by the consolidation of the Wachovia National Bank and the Wachovia Loan and Trust Company. In that same year, the modern, seven-story steel and brick structure was built on the corner of Third and Main Streets. The building was enlarged in 1918 and an eighth story was added. (Courtesy of Clarke and Della Stephens.)

THE WACHOVIA BUILDING. The tallest building in the Southeast at the time was "topped out" on March 15, 1965, to signify the completion of the major steel work. Nearly a year later, on February 28, 1966, Mayor M.C. Benton cut the ribbon to formally open the new Wachovia Building. Standing 410 feet tall on its Church Street side, the building occupies the block bordered by Main, Fourth, Church, and Third Streets. The Wachovia name was removed from the building in 1998. The renovated and refurbished building today is named Winston Tower.

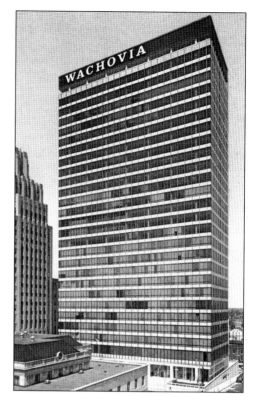

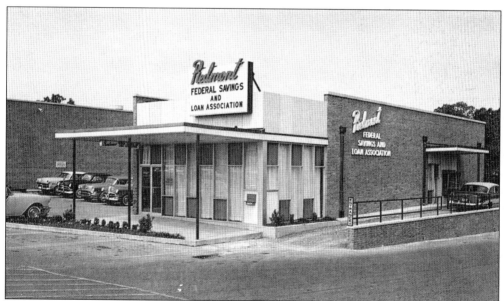

PIEDMONT FEDERAL SAVINGS AND LOAN ASSOCIATION. Piedmont Federal was founded in 1903 as the Piedmont Building and Loan Association. In 1921 it merged with Mutual Building and Loan to become Piedmont Mutual Building and Loan Association. It adopted its current name about 1933. This postcard shows its first non-downtown branch, opening in 1960, at Northside Shopping Center. The card relays the motto "old enough to know—young enough to grow."

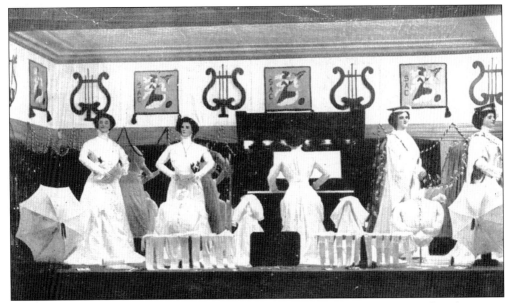

THE HITCHCOCK-TROTTER COMPANY. The 1910 display window at Hitchcock-Trotter Company featured the latest fashions for Salem Academy graduates. The store opened in 1907 on West Third Street and occupied two floors and the basement. One floor was devoted to dress fabrics, millinery, and ladies' furnishings. The second floor featured ready-to-wear garments for women, misses, and children. The company also conducted a mail-order business for out-of-town customers.

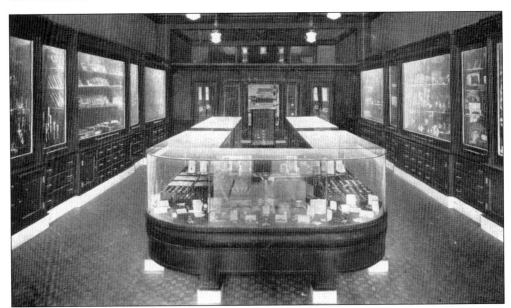

FRED N. DAY'S JEWELRY STORE. Fred N. Day became a jeweler in 1885 in Oxford, North Carolina. He opened his Winston-Salem store in 1893 and moved to the 428 North Trade Street location in 1914. This 1918 postcard shows his well-appointed store, which featured high-grade wares, jewelry, watches, and silverware. Henry B. Day, Fred's son and a graduate of Philadelphia Optical College, was in charge of the optical department.

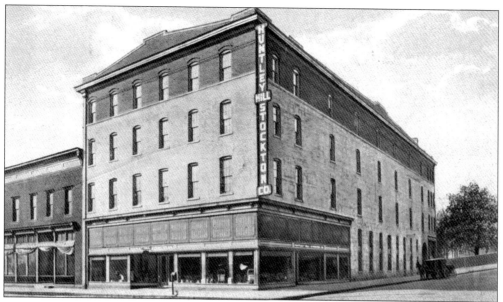

HUNTLEY-HILL-STOCKTON COMPANY. The T.L. Vaughn tobacco factory occupied the southwest corner of Fifth and Trade Street. The building was purchased by the Huntley-Hill-Stockton Company for a furniture store and featured a corner entrance with five steps. In 1911 the store was remodeled and enlarged, but it retained the original walls. In 1932 the business moved to another location on Trade Street. (Courtesy of Sarah Murphy McFarland.)

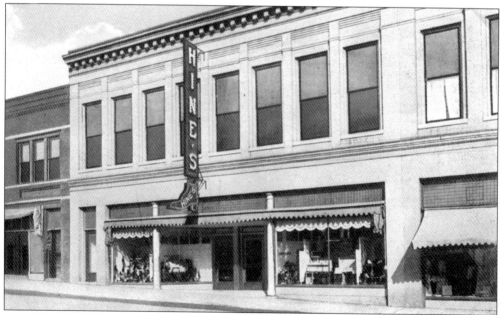

HINE'S SHOE STORE. Efird Hine opened his women's shoe store in 1911 and moved to the 211 West Fourth Street location in 1916. At that time, downtown businesses were clustered around courthouse square, and the Fourth Street location was considered "too far out." The store specialized in a good selection of quality shoes and carried other merchandise, such as luggage. The business expanded to the Stratford Mini-Mall in 1975. (Courtesy of Sarah Murphy McFarland.)

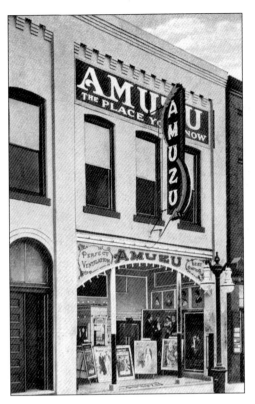

THE AMUZU THEATRE. Fans of Hoot Gibson, the famous early western film star, flocked to the Amuzu Theatre on West Fourth Street to see *The Flaming Frontier* and *King of the Rodeo*. The Amuzu opened in 1910 following the demise of its predecessor, the Lyric. Early moviegoers paid 10¢ to 25¢ for a matinee performance and up to 30¢ for an evening performance. (Courtesy of Sherry Joines Wyatt.)

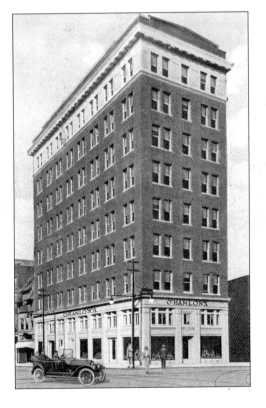

O'HANLON'S DRUG STORE. E.L. O'Hanlon opened his drug store in 1896 on the corner of Fourth and Liberty Streets. He bought the L.E. Steere drug business and operated from the three-story S.A. Ogburn Building. A fire in 1913 forced his move across the street while his new eight-story skyscraper rose in the previous location. The drug store occupied only part of the O'Hanlon Building, and it closed in 1961.

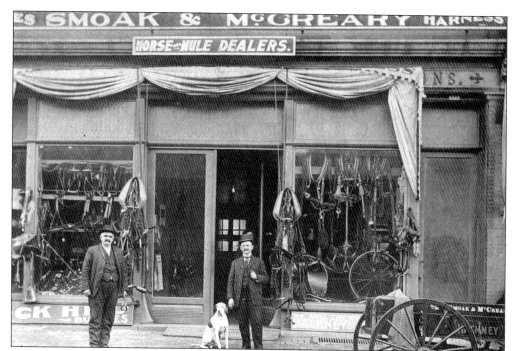

SMOAK AND MCCREARY. William W. Smoak (right) and John B. McCreary (left) advertised "the best horses and mules at lowest prices." Beginning about 1908, Smoak and McCreary sold harnesses and buggies at 432 North Main Street and operated stables at another location. When the livery business gave way to automobiles, McCreary served four terms as Forsyth County sheriff, and Smoak worked for a motor company. (Courtesy of Stephen E. Massengill.)

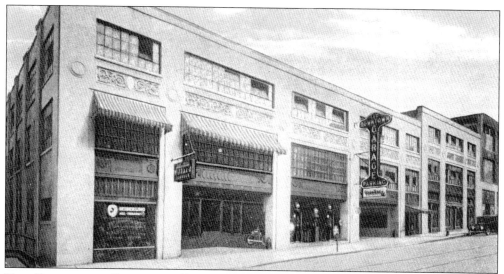

THE DOWNTOWN GARAGE. William Neal Reynolds purchased the old Brown's Warehouse and built the Downtown Garage on the lot in 1926. Northup and O'Brien designed the building with 600 spaces for automobiles on its four floors and roof. The building fronted on Main and Church Streets, near Fifth Street, extending through the block. A door later connected the garage to the Reynolds Building. (Courtesy of Clarke and Della Stephens.)

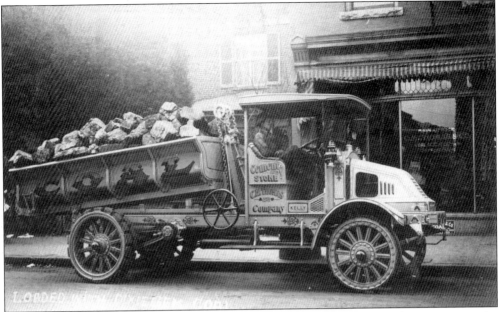

C.M. THOMAS AND COMPANY. In the early 19th century, C.M. Thomas and Company was the supplier for two necessities of life—coal and ice. In 1907 the company added the manufacture of concrete blocks to their capabilities in order to keep their facilities working year-round. They carried Dixie Gem coal, which was considered a superior product. They purchased it in large quantity to secure the lowest prices.

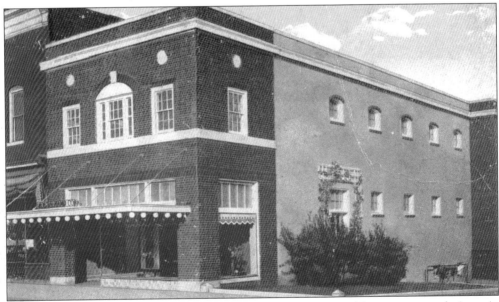

BOWEN PIANO COMPANY. R.J. Bowen began selling sewing machines, organs, and pianos in 1894. By 1903 he exclusively featured pianos. He advertised his "one price selling system" along with his patented "one man piano loader." This unique invention enabled a salesman to carry a sample piano on his Ford Runabout and demonstrate for potential buyers. The postcard shows his 513 North Trade Street location. (Courtesy of Clarke and Della Stephens.)

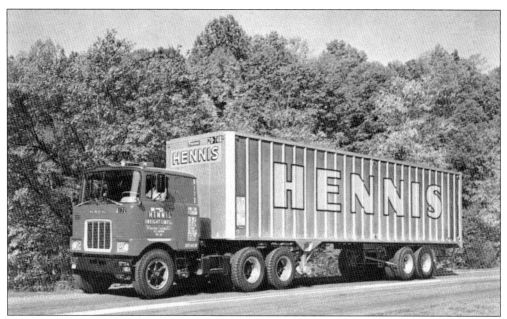

HENNIS FREIGHT LINES. Sam and Hugh Hennis of Mt. Airy founded Hennis Freight Lines in 1928. Shirley Mitchell purchased Hennis in 1946, acquiring their operating rights in the deal. In 1957 Hennis ranked as the 25th largest trucking company in gross revenue in the United States. M.C. Benton and W. Dennis Spry purchased the company in 1970. (Courtesy of Clarke and Della Stephens.)

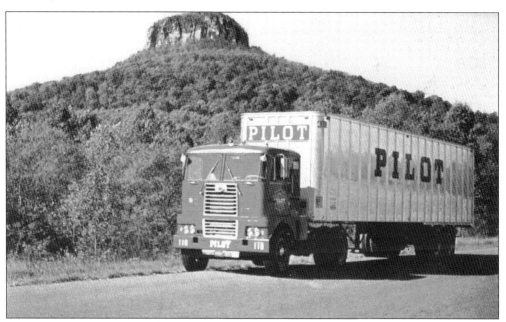

PILOT FREIGHT CARRIERS. Ruel Yount (R.Y.) Sharpe purchased Pinnix Transfer Company on December 1, 1941, and established Pilot Freight Carriers. Pilot Mountain was its namesake and a ship's wheel became the symbol of the company. Pilot Freight Carriers was a family-owned trucking firm with their executive offices located at North Cherry Street and Polo Road.

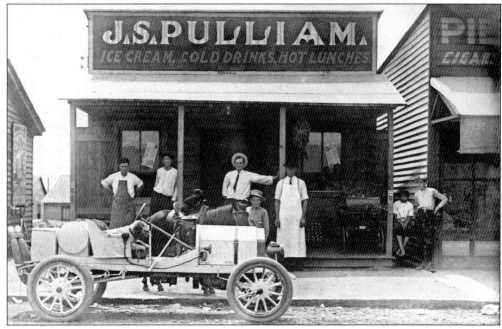

J.S. PULLIAM BARBEQUE. John Sink Pulliam Sr. opened his business in 1910 on North Liberty Street, across from the old fairgrounds. He sold groceries, produce, feed stuffs, cold drinks, ice cream, tobacco, and cigars. In 1958 Richard "Big Ed" Flynt purchased the business, which is managed today by his son and daughter, Mark Flynt and Gayla Posey. The eatery on Old Walkertown Road specializes in barbeque and hotdogs. (Courtesy of Wayne and Louise Biby.)

TOWN STEAK HOUSE. Bill and Mary Chamis opened their first Town Steak House on South Hawthorne Road in 1940. The restaurant moved around the corner to Lockland Avenue in 1956 when Interstate 40 passed through town. Thruway Shopping Center opened that same year and Town Steak House #2 was built nearby on Stratford Road. The restaurants were well known for their good food and elegant but comfortable furnishings.

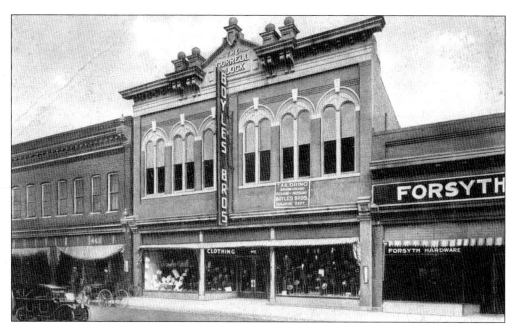

BOYLES BROTHERS CLOTHING STORE. The Boyles Brothers 1915 advertisement declares "Boyles Brothers for best clothing, hats and furnishings for men and boys. We specialize in good made and good style clothing at popular prices." Boyles Brothers was in business from 1907 until 1922, always on Trade Street. They were in this 437 North Trade Street location about 1915–1916.

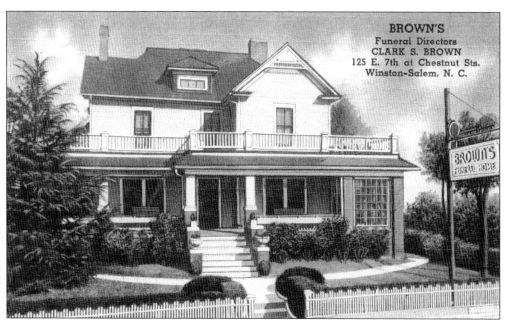

BROWN'S FUNERAL DIRECTORS. Clarke S. Brown, originally from Richmond, Virginia, was educated in New York. After coming to Winston-Salem in the early 1930s, he worked for the Fraternal Funeral Home and eventually purchased the business. Brown's Funeral Directors, renamed for the new owner, was located at Seventh and Chestnut Streets. Today, the business is Clarke S. Brown and Sons Funeral Home and is located at 727 Patterson Avenue.

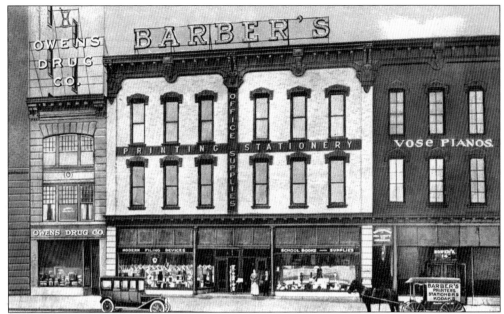

BARBER PRINTING AND STATIONERY COMPANY. This company was responsible for printing many of the Winston-Salem postcards. The company was located at 10–12 West Third Street, near the corner of Main and Third Streets. The windows of the store advertise "modern filing devices" and "school books—supplies." Other postcards printed by Barber cleverly positioned the image to capture the name of the company. (Courtesy of Sherry Joines Wyatt.)

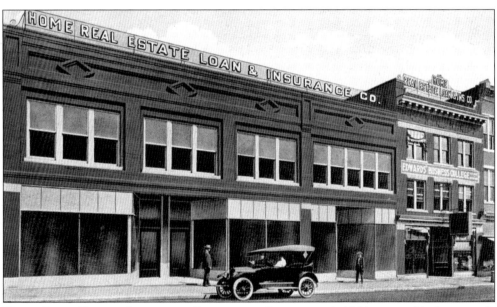

HOME REAL ESTATE LOAN AND INSURANCE COMPANY. A 1906 partnership between S. Cicero Ogburn and J.L. Vest provided the foundation for the business that exists today as Home Real Estate Company. The building shown on the postcard was built in 1911 at 511 North Liberty Street. In 1927 the company purchased several properties for R.J. Reynolds Tobacco Company to build the Reynolds Building. (Courtesy of Sherry Joines Wyatt.)

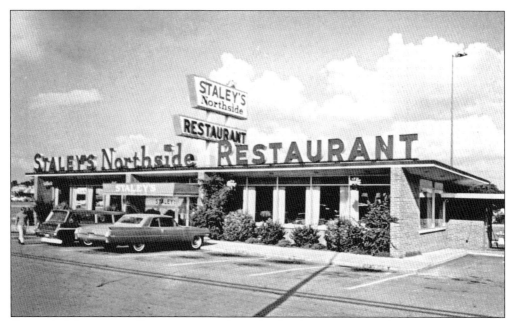

STALEY'S NORTHSIDE RESTAURANT. The Staley brothers, Wayne and Lawrence, operated a combination café and filling station at Roaring River before expanding their business to Winston-Salem in 1935. Wayne sold his interest in the partnership to Lawrence, who opened the Northside Shopping Center location in 1960. The restaurant featured curb service with 30 teletrays, plus dining room seating. At one time, Lawrence Staley owned five restaurants in Winston-Salem.

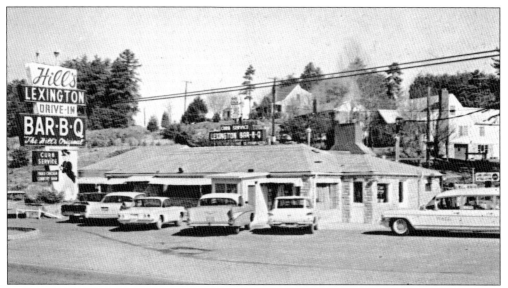

HILL'S LEXINGTON BARBEQUE. Joe and Edna Hill founded the popular barbecue restaurant on North Patterson Avenue in 1951. They were the first to use the name "Lexington Barbecue." In 1971 a new building was constructed next to the original restaurant, providing more seating for the family-owned eatery. Today, second-generation owners Gene and Sue Hill are joined in the business by third-generation Hills. (Courtesy of Clarke and Della Stephens.)

STEVE'S ITALIA RISTAURANTE. Around 1965 a retail area opened near Thruway Shopping Center on Oakwood Drive. One of the new businesses was Steve's Italia Ristaurante. Featuring "finest Italian foods" and "American cuisine," Steve's was open until about 1980, when it was replaced by the Blue Bay Restaurant. The author particularly remembers the baked spaghetti as a delicious dish. (Courtesy of Evelyn Shaw Styron.)

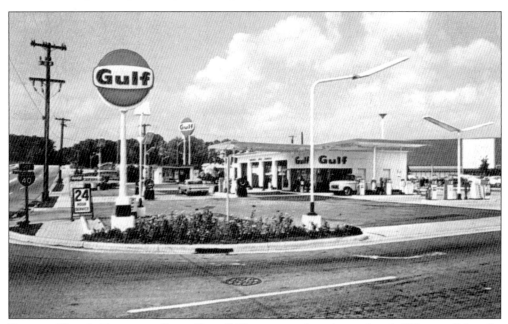

RUSSELL KING'S THRUWAY GULF. Russell King operated service stations in Winston-Salem for 42 years before his retirement in 1976. Working for Standard Oil and Gulf during his career, he took charge of the station at Thruway Shopping Center in 1964. The full-service station changed to self-service and dropped maintenance services after his retirement.

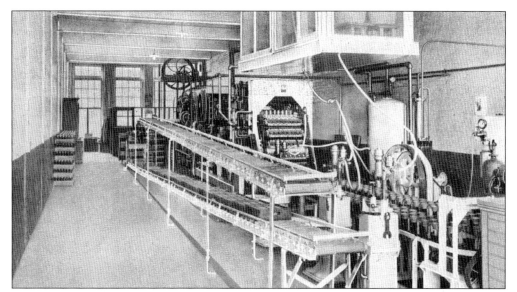

WINSTON-SALEM CHERO-COLA BOTTLING COMPANY. In Columbus, Georgia, pharmacist Claud Hatcher developed a soft drink called Chero-Cola. A bottling company opened *c.* 1916 on West Fifth Street but moved to other locations during its existence. Advertisements for the plant promised sanitary conditions and sterilized bottles. The parent company's name was originally Union Bottling Works, but it changed to Nehi Corporation and later to Royal Crown Cola Company. (Courtesy of Sherry Joines Wyatt.)

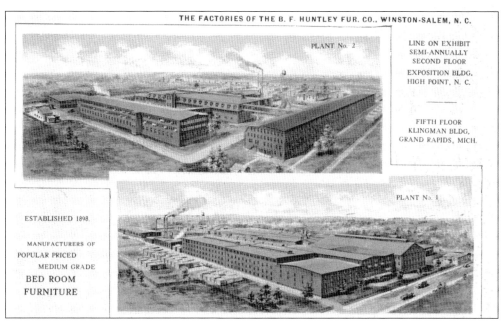

B.F. HUNTLEY FURNITURE COMPANY. Oakland Manufacturing Company, founded in 1898, was located on Depot Street. The company became B.F. Huntley Furniture Company, and the street became Patterson Avenue. The company produced mainly bedroom furniture. A February 1956 fire destroyed the Patterson Avenue plant, but a new and improved facility was built across the street. It was ready for business in only nine months. (Courtesy of Sherry Joines Wyatt.)

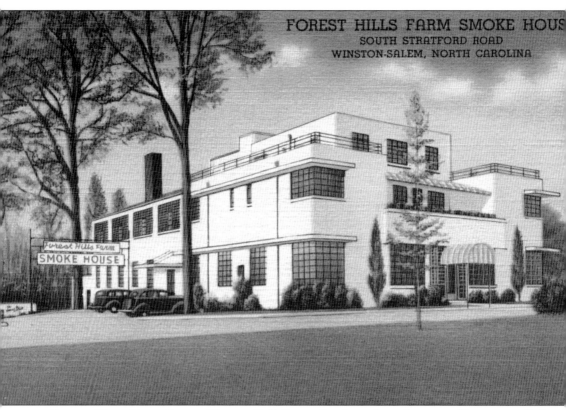

FOREST HILLS FARM SMOKE HOUSE. R.E. Lasater lived on a large farm near Clemmons called Forest Hills Farm. He worked at R.J. Reynolds Tobacco Company, grew vegetables, and raised dairy cattle and hogs on his farm. He built a mill and produced cornmeal, which bore the Forest Hills Farm label. In 1938 he helped found Selected Dairies, which was a joint venture of several businessmen who also raised dairy cattle and wanted a facility to process and distribute the milk. Selected Dairies was built on South Stratford Road and had the most modern and sanitary equipment. He also built the Smoke House nearby in the late 1930s to serve as a selling outlet for his farm products. Customers at the Smoke House could purchase meat products there or eat in the restaurant. Mr. and Mrs. Lasater lived in the large apartment over the Smoke House during the war years because of gas rationing. The building still stands today at an entrance to Thruway Shopping Center. (Courtesy of Clarke and Della Stephens.)

Six
INSTITUTIONS

Education was one of the first concerns when the early Moravians settled Bethabara in 1753, particularly after the women and children joined the settlement three years later. It is thought that Ludolph Gottlieb Bachhoff, who was Bethabara's journal keeper and proficient in English, was the teacher at the first informal school. He became Bethania's schoolmaster in 1761 and later taught in Wachovia's first school building, in the South Fork community.

The original group of 15 men who traveled to North Carolina with Bishop Spangenberg included a doctor, Br. Hans Martin Kalberlahn. Brother Kalberlahn was born in Norway and received his medical training in Europe. At Bethabara he grew a medical garden and arranged a laboratory. He also established a sickroom in the Brother's House, making this the first hospital in Forsyth County.

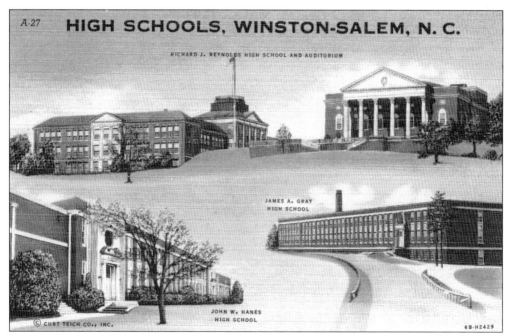

HIGH SCHOOLS. The three high schools and the auditorium featured on this postcard were built by 1930, but two schools were then known by different names. Gray High School was originally called South Junior High. It later changed to South High School and finally became James A. Gray High School. Similarly, Hanes High School was originally called North Junior High, then North High School, and finally John W. Hanes High School.

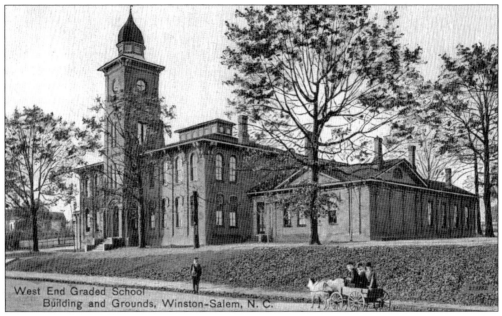

WEST END GRADED SCHOOL. Winston city leaders tried for years to fund a public school. Their efforts finally produced the West End Graded School. Dedicated May 23, 1884, it was called the "Crowning Glory of Winston." The school was located on Fourth Street near Broad and was well known for its outstanding library. Dedicated in 1886, the collection of books and periodicals later formed the nucleus of the Carnegie Library.

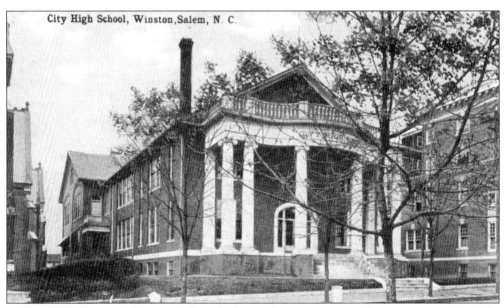

CITY HIGH SCHOOL. The YMCA bought the Hodgin property on Cherry Street in 1907. The lot between the new YMCA and the First Presbyterian Church was purchased for a new high school. City High School was built in 1908. This prime location allowed use of the YMCA next door for recreational facilities and the Carnegie Library across the street for reading and reference materials. (Courtesy of Sarah Murphy McFarland.)

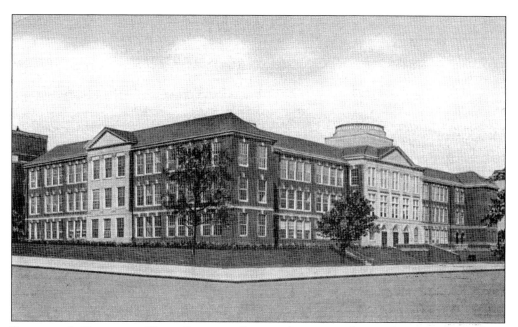

RICHARD J. REYNOLDS HIGH SCHOOL. Construction was underway for a new high school when City High School burned in January 1923. Students attended classes at St. Paul's Episcopal Church until construction at the new school finished. The author's father and seven siblings, plus brothers and other family members, attended the school on Silver Hill. The older generation walked to school and occasionally roller-skated from their Elizabeth Avenue home.

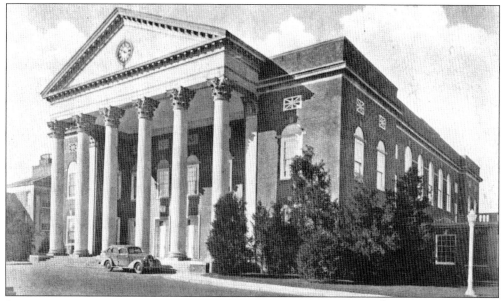

REYNOLDS MEMORIAL AUDITORIUM. The auditorium was financed by Katharine Reynolds Johnston to honor her first husband, Richard J. Reynolds, who died in 1918. Charles Barton Keen designed the auditorium to meet the physical and aesthetic needs of theatergoers. Dedicated in May 1924, the 2002 restoration has renewed and enhanced the original grandeur of the auditorium. (Courtesy of Clarke and Della Stephens.)

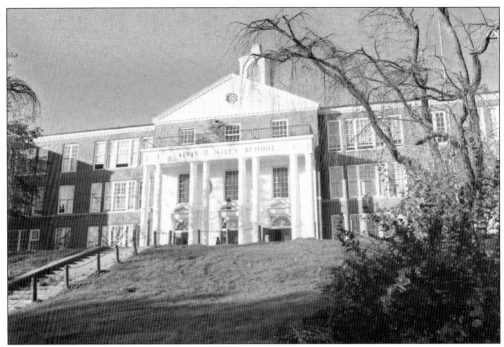

CALVIN H. WILEY SCHOOL. Dedicated in 1925, Wiley School is located on Northwest Boulevard near Hawthorne Road. Named after the chairman of Winston's first school board and North Carolina's first superintendent of schools, Wiley has been an elementary, a junior high, and a middle school. The Calvin H. Wiley monument on the school grounds originally graced the school on West Fourth Street that Dr. Wiley helped found, West End School.

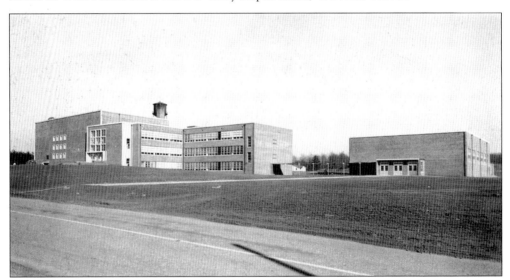

MINERAL SPRINGS HIGH SCHOOL. The first new high school built in Forsyth County in 19 years cost $1 million. Mineral Springs High School was dedicated December 3, 1948, in the new 1,153-seat auditorium. Built on 30 acres at Ogburn Avenue and Motor Road, the exterior was brick and the interior walls were cinder blocks painted pastel shades of green and yellow. (Courtesy of Sarah Murphy McFarland.)

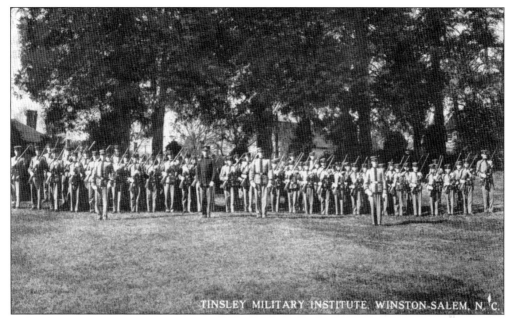

TINSLEY MILITARY INSTITUTE. This 1912 postcard shows the cadets of the day and boarding school founded by J.W. Tinsley. The school existed from 1910 to 1913 and was located in a building at Fourth and Cherry Streets and later housed in the Salem Boys' School building on South Church Street. Several of the students became notable citizens, but the school had a brief existence. (Courtesy of Sarah Murphy McFarland.)

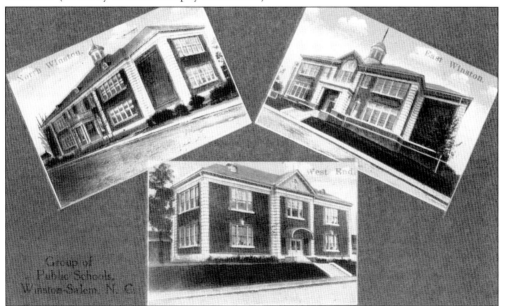

WINSTON PRIMARY SCHOOLS. Three primary schools were built in Winston in 1911. East Winston, upper left on the postcard, was located at Highland and Seventh Streets. North Winston, upper right on the postcard, was located on Patterson Avenue. West End, bottom of the postcard, was located on Broad Street. The publisher of the postcard mislabeled the school names of the upper right and left schools. (Courtesy of Clarke and Della Stephens.)

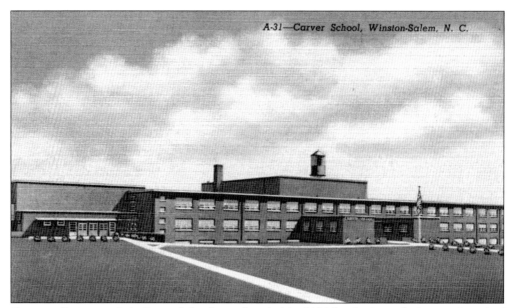

CARVER SCHOOL. Oak Grove School was founded in 1936 by the Forsyth County Board of Education for the county's African-American students. The class of 1939 was the first to graduate from Oak Grove School, which later became Carver School. A new school was built in 1951 and housed students in grades 1 through 12. After serving as a junior high school, Carver is now a high school.

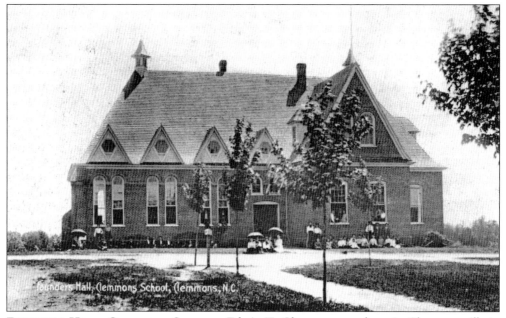

FOUNDERS HALL, CLEMMONS SCHOOL. Edwin T. Clemmons was born in Clemmonsville in 1826 and attended Salem Boys' School. He operated the Clemmons stagecoach and later moved to Asheville to become a hotel proprietor. After his death in 1896, his will provided funds to establish an educational facility, and Clemmons School was founded in 1900. This 1907 postcard shows the Founders Hall, built *c.* 1902.

LEWISVILLE HIGH SCHOOL. The third Lewisville High School was built in 1948 on the same property as its predecessors. The school began as Lewisville Academy in 1901 and became a four-year high school in 1911. The original structure was demolished in 1923 and replaced with a brick building that burned in 1945. The school is located off Shallowford Road, across from the Lewisville Library. (Courtesy of the Lewisville Historical Society.)

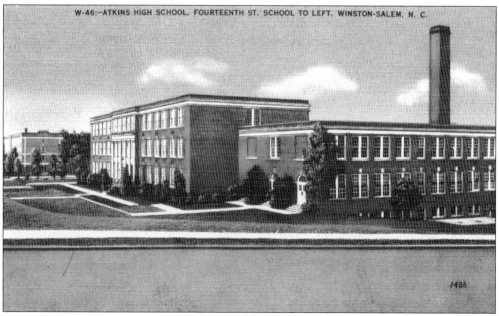

ATKINS HIGH SCHOOL AND FOURTEENTH STREET SCHOOL. Atkins High School (now a middle school) is located on Cameron Avenue at 12th Street. The high school was dedicated on April 2, 1931, and named after Dr. Simon Green Atkins, first president of Winston-Salem State University. Fourteenth Street School, on the left of the postcard, was built in 1924 at Cameron Avenue and 14th Street for elementary students.

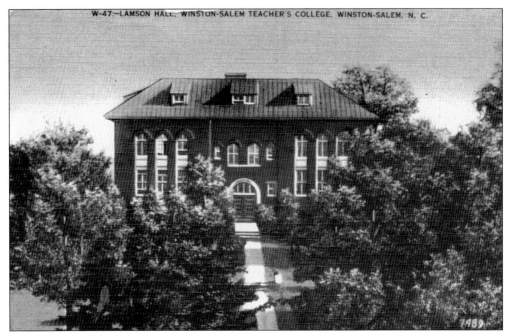

LAMSON HALL. Slater Industrial Academy's first brick building, Lamson Hall, was three stories tall and built in 1896. The basement contained the kitchen and dining hall for boarding students, plus household arts classrooms. Four classrooms and administrative offices filled the first floor. A chapel and female faculty living quarters occupied the second floor. Fourteen dorm rooms for girls were located on the third floor. The building was demolished in 1939.

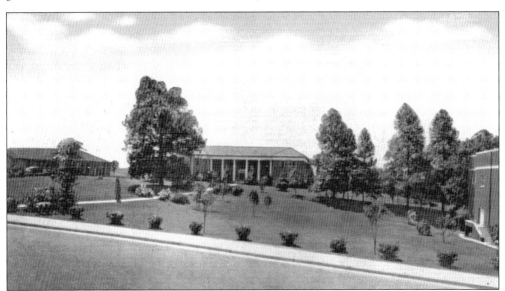

WINSTON–SALEM TEACHER'S COLLEGE. Founded by Dr. Simon Green Atkins, Slater Industrial Academy opened September 28, 1892. In 1925 the school came under state control as a four-year institution for black students, and the name was changed to Winston-Salem Teacher's College. Other name changes in 1963 and 1969 resulted in the current school name, Winston–Salem State University. In 1971 the school became part of the University of North Carolina system.

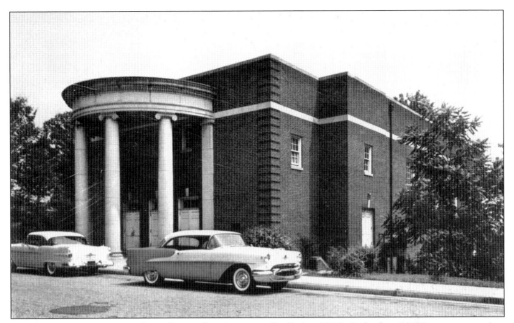

FRIES AUDITORIUM. When the auditorium was built in 1939, it had a 1,000-person seating capacity and featured the latest in stage scenery and lighting. Named for Henry E. Fries, chairman of the board of trustees since Slater's founding, the building also contained rooms for piano practice and instruction. The building collapsed on June 13, 1970, after a heavy rain. O'Kelly Library was built near this location.

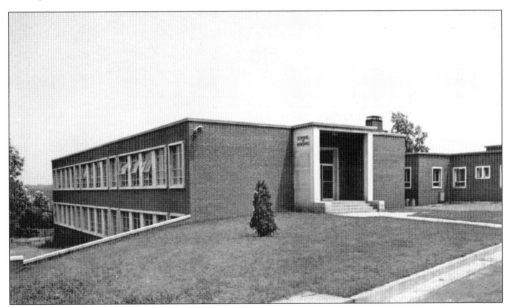

SCHOOL OF NURSING. In 1899 the State granted Slater a new charter and renamed it Slater Industrial and State Normal School of Winston-Salem, North Carolina. The school began efforts to establish a hospital and nurse training department. Slater Hospital opened May 14, 1902, financed by contributions from Richard J. Reynolds and money raised by Dr. Atkins. A four-year nursing school was established in 1953. (Courtesy of Clarke and Della Stephens.)

WAKE FOREST COLLEGE. Wake Forest Institute was founded in 1834 and became a college in 1838. The college resided in the town of Wake Forest, North Carolina, until it moved to Winston-Salem in 1956. President Harry Truman, Charles Babcock, Hubert Olive, and other dignitaries broke ground for the college on October 15, 1951. Winston-Salem residents lined the six-mile route from the airport to the campus to see President Truman.

WAIT CHAPEL. The writer of this 1958 postcard remarked that he was given a "terrific" tour of the new campus. A tour would certainly include Wait Chapel, the imposing building at the head of the college square. The chapel was named for Samuel Wait, the college's first president and a prime figure in organizing the Baptist State Convention. The first campus, located in Wake Forest, North Carolina, included Wait Hall, which burned, and then was rebuilt in 1934.

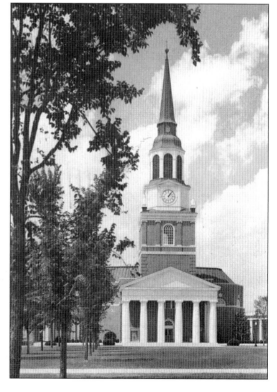

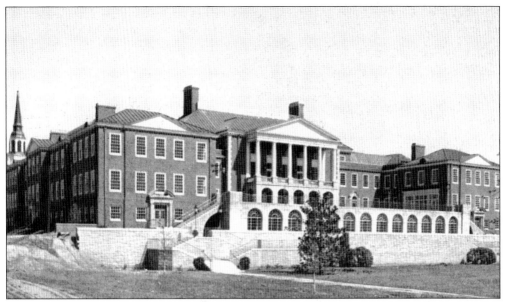

REYNOLDA HALL. Charles and Mary Reynolds Babcock donated the 300-acre site for Wake Forest College in Winston-Salem. Funds to build the college came from North Carolina Baptists, the people of Forsyth County and Winston-Salem, alumni and friends of the college, and income from the Z. Smith Reynolds Foundation. Reynolda Hall, located across the campus from Wait Chapel, housed the student activity center, administrative offices, and meeting and banquet facilities.

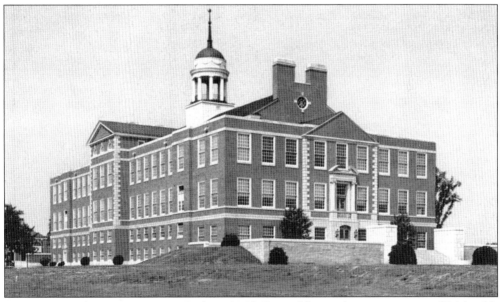

Z. SMITH REYNOLDS LIBRARY. Zachary Smith Reynolds was the youngest son of Richard J. Reynolds. The foundation that bears his name helped fund Wake Forest's move to Winston-Salem. The library was named for Z. Smith Reynolds. In 1991 the library underwent an extensive renovation and addition that expanded its size and technological capabilities. Today the library covers 173,000 square feet and houses over a million volumes.

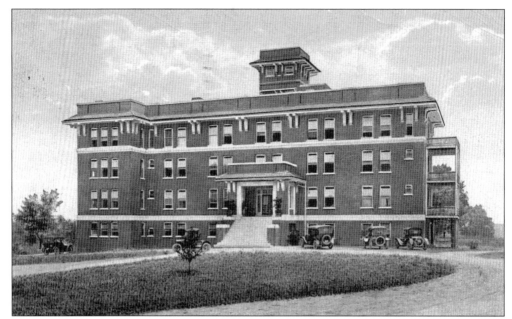

TWIN CITY HOSPITAL. The first Twin City Hospital opened in 1895 on Brookstown Avenue. Mrs. James A. Gray led a group called the Ladies' Twin City Hospital Association in their efforts to establish a hospital. Their first hospital was in the rented Martin Grogan house on North Liberty Street. When this facility became inadequate, they selected the Brookstown lot and built and paid for the new hospital before it opened. The Brookstown Avenue hospital served the city until it closed in 1911. A new Twin City Hospital (shown above) opened in 1914 in the eastern part of Winston-Salem with 90 beds, built on five acres of land donated by R.J. Reynolds. Admissions continued to increase, and two additional wings were added to raise the bed count to 225 (shown below). More additions were made to the buildings in the succeeding years.

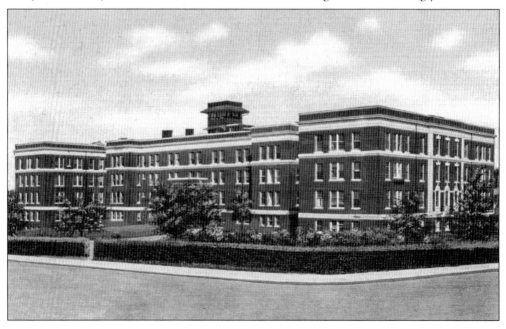

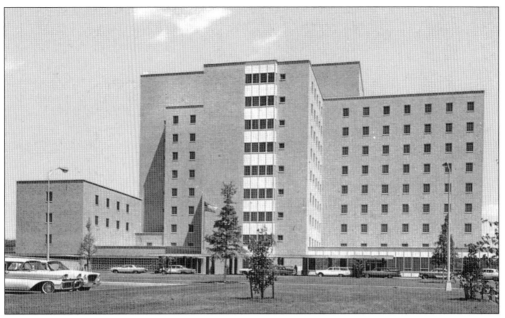

FORSYTH MEMORIAL HOSPITAL. As early as 1936, there was a resolution to build a new hospital in the western part of the city. Forsyth Memorial Hospital, built on 77 acres at the end of Hawthorne Road at Silas Creek Parkway, opened in April 1964. City residents stood in line to tour the facility and marveled at the spaciousness and modern equipment. The new hospital cost $15 million and had 540 beds.

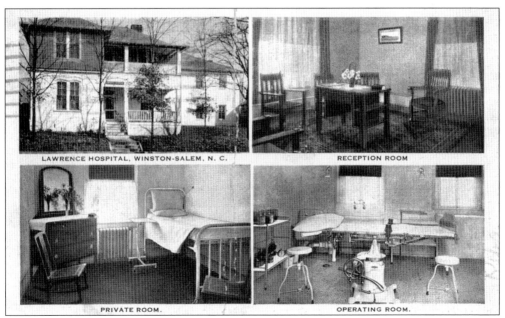

LAWRENCE HOSPITAL. The writer of this 1929 postcard reported on the condition of a patient whose ailment was not disclosed. The patient is resting better, just beginning to get over the ether, and "not suffering as much as this morning." The 56-bed hospital was opened by Dr. Charles Lawrence in 1920 on Oak Street and closed in 1933. The building was later used for apartments.

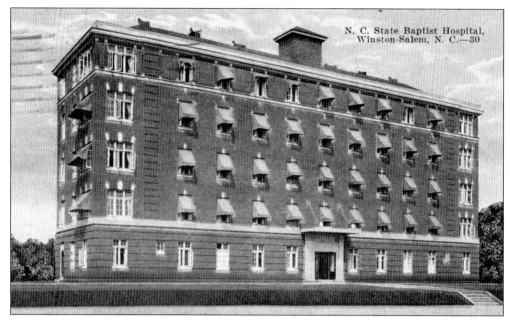

NORTH CAROLINA BAPTIST HOSPITAL. The Hospital Commission of the Baptist State Convention chose Winston-Salem as the site for a new hospital in North Carolina. The first building was 5 stories tall, with 88 beds and 20 bassinets, and was dedicated May 28, 1923. This postcard was mailed in 1930 by a Salem Academy student to a former classmate from Mocksville High School.

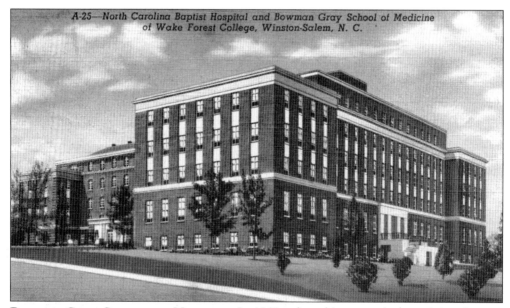

BOWMAN GRAY SCHOOL OF MEDICINE. In 1945, when this postcard was written, the new West Wing had been added to the Baptist Hospital. Also, the two-year medical school had moved to Winston-Salem from Wake Forest, North Carolina, to become a four-year school and was named Bowman Gray School of Medicine. The writer of the postcard asked if her correspondent had some lard to spare—two or three gallons.

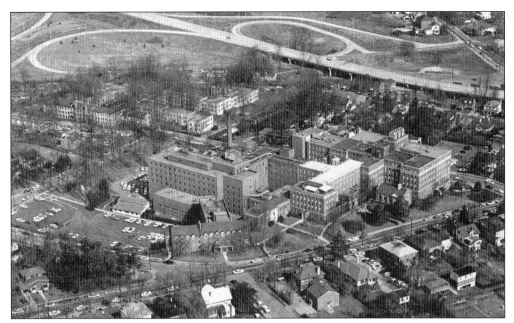

AERIAL OF BAPTIST HOSPITAL AND MEDICAL SCHOOL. This aerial postcard shows the growth and expansion of the hospital and medical school from their earlier days. The complex is framed by Hawthorne Road, near the bottom of the photo, and Interstate 40, near the top. The group of buildings in the upper left corner is the Twin Castles Apartments, which were purchased by the hospital in 1959 to house paramedical students.

BAPTIST HOSPITAL NURSES' HOME. A nursing school opened in the summer of 1923, with the nurses living on the fifth floor of the Baptist Hospital. In 1928 a three-story nurses' home was built on the corner of Hawthorne Road and Queen Street with classroom space in the basement. The building was later used as the Progressive Care Center of the hospital.

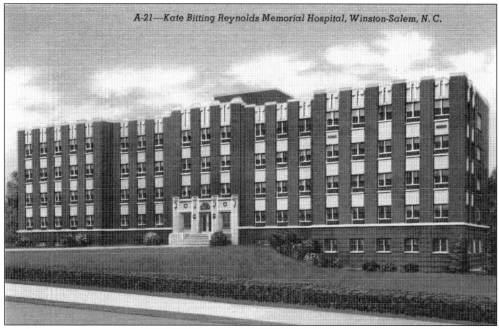

KATE BITTING REYNOLDS MEMORIAL HOSPITAL. William Neal Reynolds contributed $115,000 towards a new hospital to be built in East Winston. The hospital was completed in July 1938 with 100 beds and was named for Mr. Reynolds' wife, Kate Bitting Reynolds. Mr. Reynolds later donated funds for additions and repairs to the hospital.

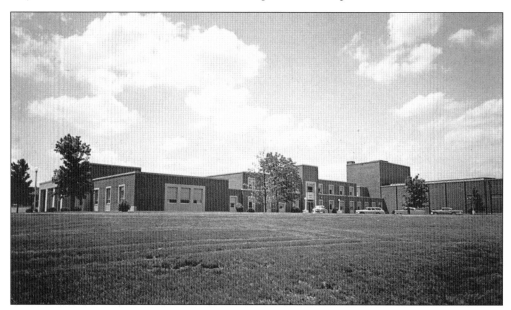

JAMES G. HANES COMMUNITY CENTER. The center on Coliseum Drive was built to house the United Fund, Arts Council, and Chamber of Commerce. John D. Rockefeller III spoke at the dedication on November 9, 1958. The center was named for James Gordon Hanes, former chairman of the Board of Hanes Hosiery Mills. Mr. Hanes, well known for his public service, had been a board member for all three agencies.

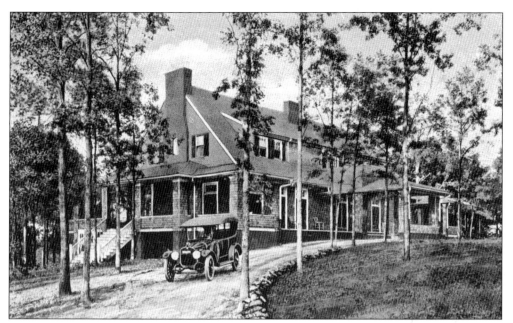

FORSYTH COUNTRY CLUB. The grand and elegant clubhouse today, which has undergone several expansions and renovations, bears little resemblance to the original clubhouse with its wooden porch and shingles. William Neal Reynolds was a founder and the first president of the club, which incorporated in 1913. The original tract of land on the Lewisville Road (renamed Country Club) included 116 acres and later grew to 170 acres.

FORSYTH COUNTRY CLUB GOLF COURSE. Club founders sought to develop property to include "golf links, tennis courts, ball grounds, and a bowling alley." The first golf course had nine holes. Golfers began playing while the terrain was still very rough. William Neal Reynolds donated 50 acres of adjoining land in 1922, and the course increased to 18 holes. (Courtesy of Stephen E. Massengill.)

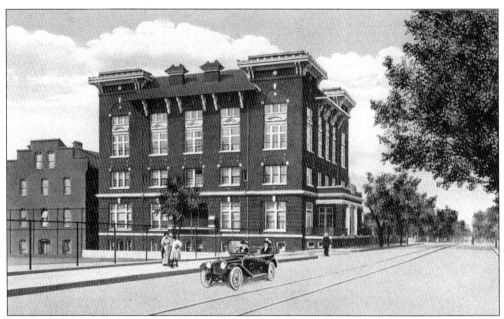

THE TWIN CITY CLUB. Ten leading citizens founded the Twin City Club in 1884, with 30 charter members and W.A. Whitaker as the club's first president. The club met in several locations until the three-story Twin City Club, on the corner of Marshall and Fourth Streets, was built in 1910. The building was sold in 1951 and replaced by J.C. Penney, with new club facilities on the fourth floor. (Courtesy of Sherry Joines Wyatt.)

SCIWORKS. The Science Center and Environmental Park of Forsyth County, SciWorks, was founded in 1964 by the Junior League and the Winston-Salem Parks and Recreation Department. Originally called the Nature Science Center and located at Reynolda Village, the Winston-Salem Foundation funded the venture. In 1972 the center occupied the former Forsyth Home facilities on Hanes Mill Road and then constructed a new building in 1992, which was expanded in 2002.

Seven
HOUSES OF WORSHIP

The Methodist Protestants built the first church in Winston, at the corner of Liberty and Seventh Streets, in 1850. The original small frame building was replaced later by a brick church. At one time, the Moravians discouraged other denominations from organizing in the areas around Salem. Some denominations kept their distance out of respect for the Moravians. Once the Methodists became established, however, other denominations followed. Relationships generally flourished among the churches.

Postcards of the downtown churches show the changes as wooden structures were replaced with brick or stone buildings, sometimes in the same location. Several churches were situated close to each other on Fourth, Fifth, and Cherry Streets. One can only imagine a Sunday morning scene in downtown Winston-Salem, with the church bells ringing and people walking to church from their nearby homes.

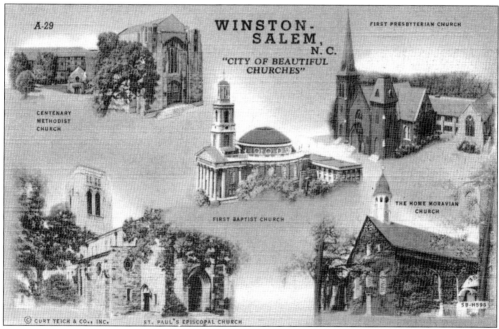

WINSTON-SALEM, "CITY OF BEAUTIFUL CHURCHES." This postcard represents the four largest downtown churches and denominations: First Baptist, Centenary Methodist, First Presbyterian, and St. Paul's Episcopal. The fifth church pictured above is Home Moravian Church in Old Salem. All five of these churches exist today in the locations shown on the postcard. Many have spawned mission churches that extend into the city's suburbs. (Courtesy of Sarah Murphy McFarland.)

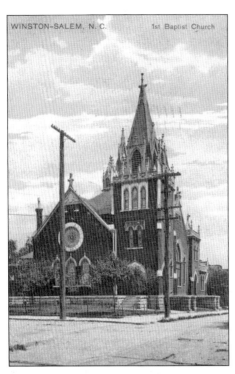

FIRST BAPTIST CHURCH, SECOND STREET. The Baptist denomination began with a small group when they met in 1871 at Winston's first courthouse. They obtained the part-time services of a minister and built a brick church on Second Street in 1876. Dr. Henry A. Brown began his 40-year pastorate in 1877. During his tenure, this new church was constructed in 1901, next to the old church. (Courtesy of Evelyn Shaw Styron.)

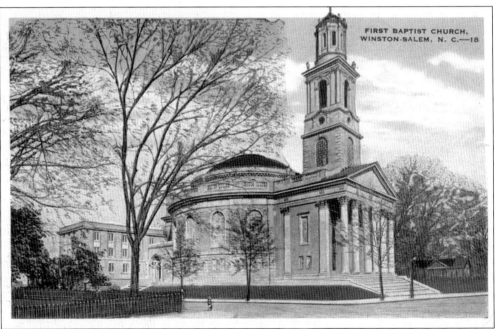

FIRST BAPTIST CHURCH, FIFTH STREET. In 1892 the church became First Baptist Church of Winston. Membership continued to grow under Dr. Brown and succeeding pastors. Plans began for a new church. The land was secured on West Fifth Street and the cornerstone laid in 1924. The first service was held in the new building in 1925. Other facilities added since then include the educational building and the Reich Chapel.

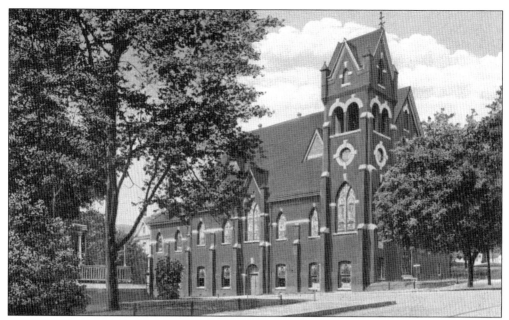

BROWN MEMORIAL BAPTIST CHURCH. Broad Street Baptist Church was organized in 1889. A new church was begun in 1906, named in honor of the long-time minister of First Baptist Church, Dr. Henry A. Brown. The interior was completed in 1911, and the church hosted the Baptist State Convention that same year. Brown Memorial and First Baptist merged in 1935. The building was later used as the Greek Orthodox Church. (Courtesy of Sherry Joines Wyatt.)

COLLEGE PARK BAPTIST CHURCH. The church near the intersection of Reynolda and Polo Roads began as a mission of First Baptist Church. After World War II, many families built homes in the Reynolda Road area and wanted to attend church closer to home. The church was constituted and the first building was erected in 1949. The author and her family are lifelong members of College Park Baptist Church.

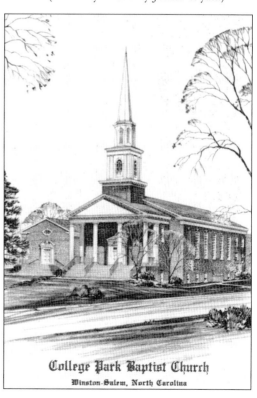

College Park Baptist Church
Winston-Salem, North Carolina

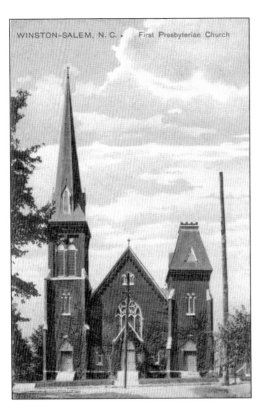

FIRST PRESBYTERIAN CHURCH. The Presbyterians formally organized and dedicated their first church in 1862. Judge T.J. Wilson was instrumental in organizing the church and in securing the lot at Third and Cherry Streets. In 1890 the church on this postcard was built on the same location. The members raised the funds, and the women contributed money to pay for the lights and a new pipe organ.

FIRST PRESBYTERIAN CHURCH. In its early days Cherry Street was lined with beautiful homes. It has always been the location of First Presbyterian Church. The church sanctuary was demolished in 1970 and replaced with a new $1.8 million sanctuary and renovated educational building. During the building and renovation, the church met in the Salem Fine Arts Center. The building was dedicated in 1972. (Courtesy of Clarke and Della Stephens.)

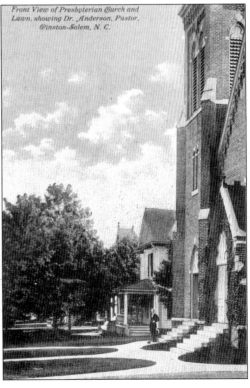

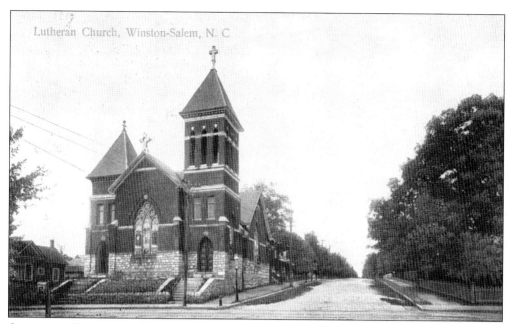

AUGSBURG LUTHERAN CHURCH, FOURTH STREET. Rev. W.A. Lutz helped the Lutherans organize in 1891 and became Augsburg's first full-time pastor. The name "Augsburg" came from the Augsburg Confession of 1530, the main creed of the Lutheran Church. The congregation purchased a lot from P.H. Hanes on the corner of Fourth and Spruce Streets. The brick and stone church was dedicated in 1895, delayed because of difficult financial times.

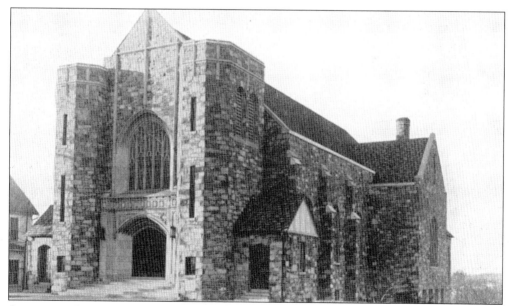

AUGSBURG LUTHERAN CHURCH, FIFTH STREET. The church that began with 46 charter members outgrew its Fourth Street facility. Two lots were purchased for a new church on the north side of Fifth Street, between Broad and Summit Streets. The stone church was first used on September 4, 1927. Augsburg celebrated its 100th anniversary in 1991. The Family Life Center is the newest addition to the church complex.

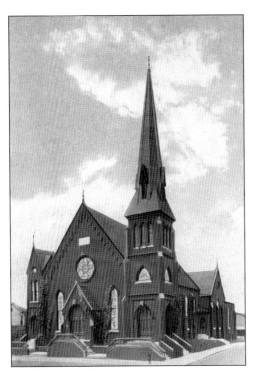

CENTENARY METHODIST EPISCOPAL CHURCH. The first Centenary Methodist Church was built on the corner of Liberty and Sixth Streets in 1886. The name Centenary was chosen because the church construction began in 1884, the 100th anniversary of the Methodist Episcopal Church in the United States. The church spire was extremely tall and rose above all other buildings in town. (Courtesy of Sherry Joines Wyatt.)

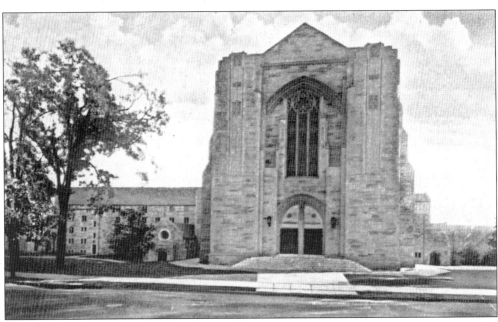

CENTENARY METHODIST CHURCH. A new Centenary was planned that could accommodate the congregations from the old Centenary and the West End Methodist Churches. The churches decided in 1927 to unite, and a new church was begun in 1929. Bowman Gray donated his home, and that of William N. Reynolds, on West Fifth Street for the church site. The church was completed in 1931. (Courtesy of Clarke and Della Stephens.)

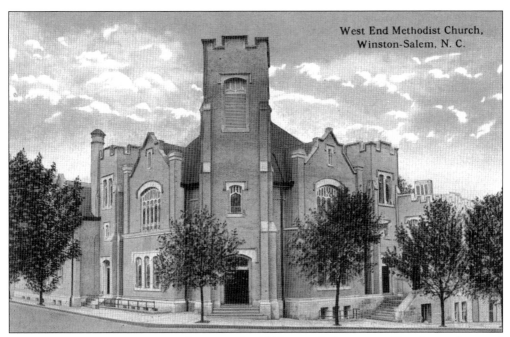

West End Methodist Church,
Winston-Salem, N. C.

THE WEST END METHODIST CHURCH. In 1909 several Centenary Church members and leaders left to begin a new church in West End. They first met in the West End Graded School, later building a church in 1913. The handsome church stood at the corner of Brookstown Avenue and Fourth Street. It was abandoned in 1931, when the two congregations reunited and moved into the new Centenary Church on Fifth Street.

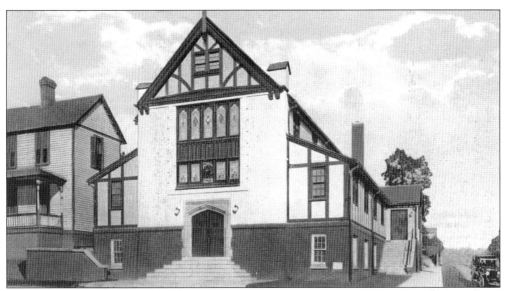

GRACE METHODIST EPISCOPAL CHURCH. Grace Church was organized in 1893 with 35 charter members. The first church building was erected during this time. The Winston Development Company, led by James A. Gray, donated the church site and the parsonage lot. The church building on the postcard was built in 1917, on the same site as the original church, the corner of East Fourth Street and Woodlawn Avenue.

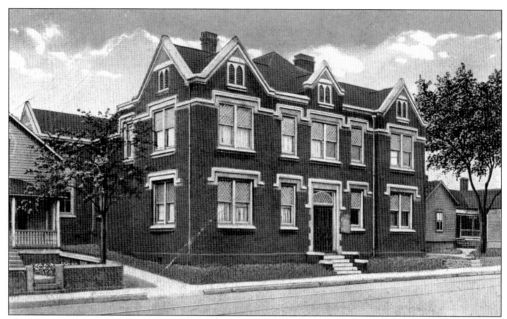

BURKHEAD INSTITUTIONAL METHODIST EPISCOPAL CHURCH. Burkhead Methodist Church began as an outgrowth of a Sunday school conducted by representatives of Centenary Methodist Church in 1886. The church was named for Dr. L.S. Burkhead, minister of Centenary, who died in 1887. Located at 1010 North Liberty Street, the church building was later used by Industries for the Blind.

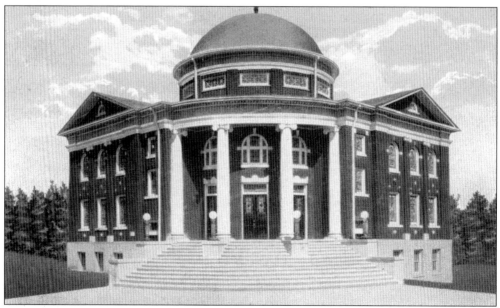

BURKHEAD METHODIST EPISCOPAL CHURCH. A new church was built in 1922 at 15th and English Streets. The neighborhood around the church changed and members moved away. A new church, with fellowship hall and Sunday school classrooms, was built on Silas Creek Parkway. The first service was held December 12, 1965. The sanctuary was built later, with the first service on August 5, 1979. (Courtesy of Clarke and Della Stephens.)

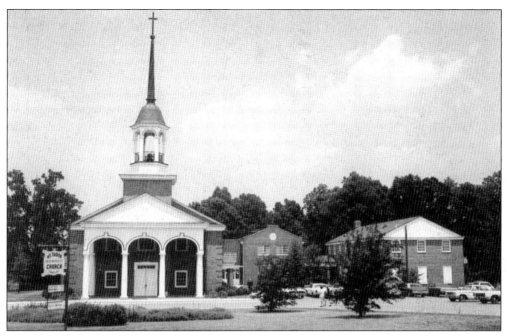

MT. TABOR UNITED METHODIST CHURCH. The church's history dates to 1845, when a circuit preacher named John Alspaugh selected a site to hold camp meetings. In 1851 trustees were elected for the Mount Tabor Meeting House. A log church was built in 1853 and then a brick church in 1888. Other buildings were constructed on the same site, including a new sanctuary in 1967. The church is located on Robin Hood Road.

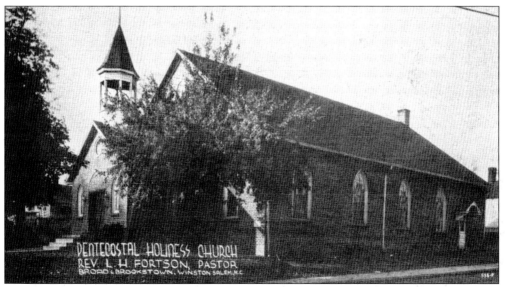

PENTECOSTAL HOLINESS CHURCH. The brick church at the corner of Brookstown and Broad Streets was built in 1937 and opened in 1938. Church members worshiped here until a new facility was built in 1970 on Hutton Street. The church was organized in 1908 and first met in the Fries Power House, the flat-iron building at Brookstown and Marshall Streets. (Courtesy of Clarke and Della Stephens.)

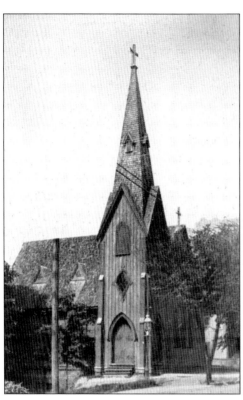

ST. PAUL'S EPISCOPAL CHURCH, FOURTH AND MARSHALL STREETS. The Episcopal denomination began in Winston about 1876 when Rev. William Shipp Bynum traveled from Greensboro to hold services once a month. The congregation increased and funded the church at the corner of Fourth and Marshall Streets. The church was consecrated in February 1879 and named St. Paul's. The Twin City Club and J.C. Penney's were later built at this location.

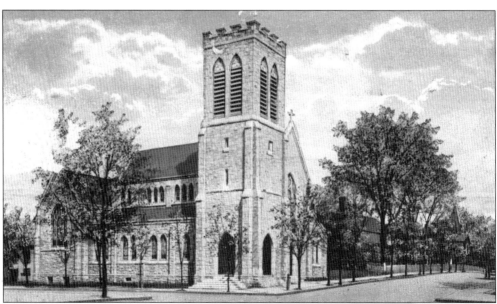

ST. PAUL'S EPISCOPAL CHURCH, FOURTH AND CHERRY STREETS. The congregation needed a larger church, so they moved one block to the east. This 1917 postcard shows the church with its entrances on both Fourth and Cherry Streets. The church was consecrated May 11, 1910, and the final service was held September 1, 1929. Frank A. Stith Company, a men's and boys' clothing store, later occupied the site.

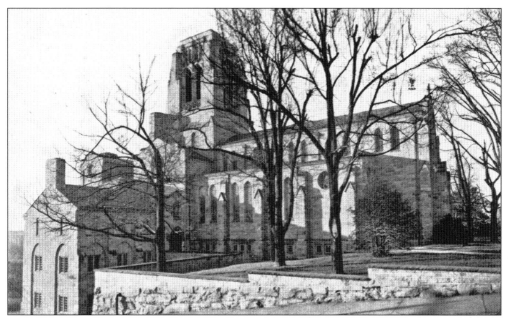

ST. PAUL'S EPISCOPAL CHURCH, SUMMIT STREET. This 1939 postcard image was taken by Bayard Wootten, an eastern North Carolina photographer who took many photographs that appeared on postcards. The new St. Paul's, designed in gothic architecture, was built on the site of J.C. Buxton's Summit Street home in 1929. Because of the varying land elevation, St. Paul's has entrances on many levels. (Courtesy of Clarke and Della Stephens.)

FRIES MEMORIAL MORAVIAN CHURCH. Mrs. Esther White began a Sunday school in her home for her son and neighborhood children in 1876. This was the beginning of the East Salem Sunday School, which was organized as a church in 1889. A new church was built on East Fourth Street and Claremont Avenue and opened in 1915. The church was named in honor of Henry and Rosa Fries. (Courtesy of George Hege.)

FRIEDBERG MORAVIAN CHURCH. A service at the home of Adam Spach in 1759 marked the beginning of the Friedberg Church, which was officially organized in 1773. A stone church was built in 1788, forming the foundation of the 1827 church, which was remodeled several times. In 1976 the church announced plans to build a new sanctuary, shown in this postcard, and completed in 1980. (Courtesy of George Hege.)

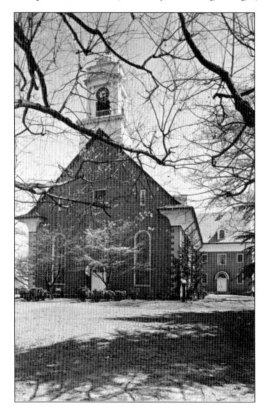

CALVARY MORAVIAN CHURCH. Calvary Chapel was the first Moravian church established in Winston. Located at 600 Holly Avenue, Calvary was organized as a congregation in 1893. The church is located on what was called the Moravian Reservation and contained a spring that served as one of Salem's earliest water supplies. A new sanctuary was constructed in 1926 and dedicated in 1931 by Bishop Edward Rondthaler. (Courtesy of George Hege.)

Eight
LODGING

The Winston-Salem Chamber of Commerce hired Dr. D.P. Robbins to compose a booklet to extol the resources and advantages of the city as a place to live and do business. Dr. Robbins' booklet, published in 1888, examined the current situation in Winston-Salem and pointed out deficiencies. One deficiency was the lack of a first-class hotel. He wrote "Every progressive city that expects to succeed, and especially in the South, should have its tourist home . . . where those who can and will pay fancy rates, may secure every needed comfort."

Apparently, these words fell on responsive ears. Just four years later, the Zinzendorf Hotel opened in West End, with the location and the accommodations to accomplish this goal. Unfortunately, its short life was abruptly ended by fire, but the seed was planted that would bloom in later hotel building projects.

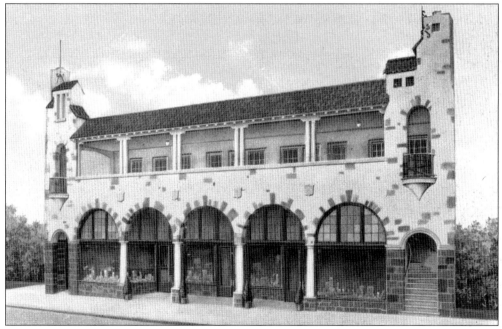

MARY ELIZABETH APARTMENTS. The Mediterranean-style building, at the foot of Summit Street on West End Boulevard, was built in 1927. Located across from Hanes Park, the building was planned to house residential and commercial tenants. Summit Street Pharmacy occupied the ground floor and featured a soda fountain that extended the length of the building. The close proximity to Reynolds High School made the pharmacy a popular spot for young people.

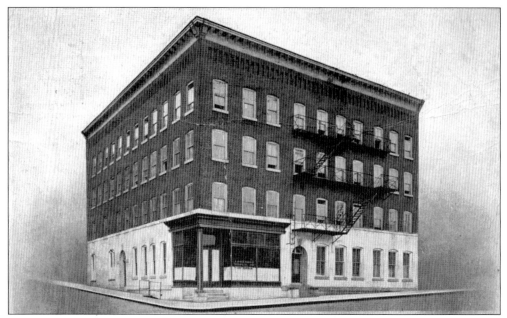

THE REYNOLDS INN. Favorable wages at R.J. Reynolds Tobacco Company attracted country girls to the cigarette plants in early 1918. Katharine Smith Reynolds, wife of R.J. Reynolds, was concerned about having clean and safe housing for these young women. The Reynolds Inn for Girls opened in 1918 at the corner at Chestnut and East Third Streets, opposite the Union Railroad Station and Reynolds Factory #12. The building in this strategic location was previously used for the Webster and Plaza Hotels. (Courtesy of Sarah Murphy McFarland.)

The Reynolds Inn. The inn contained 60 bedrooms with running water, baths, a dining room, a kitchen, and a lobby on the first floor. Rooms in the inn cost $4.00 or $4.25 per week and included two meals a day and three meals on Sunday. The inn operated as a rooming place for women until about 1929. The cafeteria continued to provide meals for company employees, with the other floors used for storage. The building was demolished in 1960. (Courtesy of Sarah Murphy McFarland.)

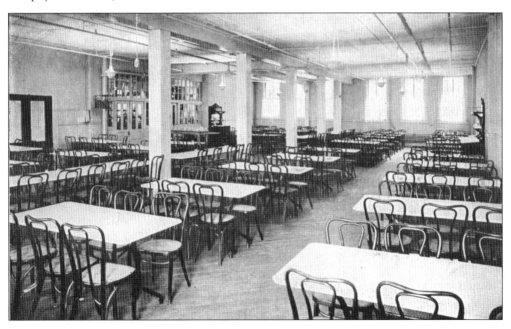

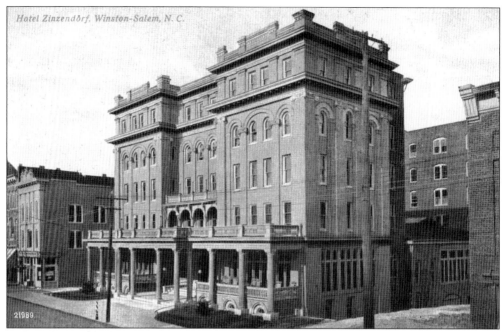

Hotel Zinzendorf, Winston-Salem, N.C.

21989

THE ZINZENDORF HOTEL. The original Zinzendorf Hotel was built as a resort in May 1892 on a hill in West End. A fire on Thanksgiving Day in 1892 destroyed the hotel and dashed the hopes of its financial backers who envisioned this area as a resort destination. In 1905 some of the same shareholders formed the Forsyth Hotel Corporation and announced a new "Forsyth Hotel" to be built on Main Street near Third Street.

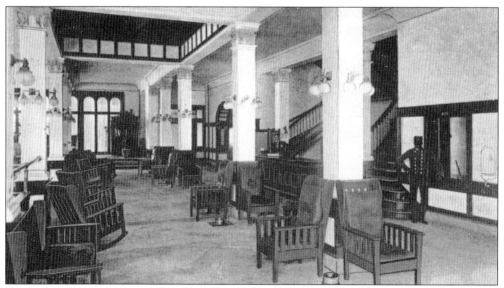

ZINZENDORF HOTEL LOBBY. The new hotel, also named after Count Nicholas Zinzendorf, opened in September 1906. The 6-story building had 120 rooms, a lobby, dining room, ballroom, and other public spaces. The lobby, described as "large, lofty, and well-lighted," featured terrazzo floors. Off the lobby to the left was a reading room, with a writing room to the right, all furnished with oak furniture of English design.

106

Zinzendorf Hotel and Grill. In 1906 telephones and washstands, with hot and cold running water in each bedroom, were modern features. Thirty bedrooms had private baths. Velvet carpet, maple and birch furniture, brass beds, and leather chairs in the bedrooms made luxurious accommodations. In its early days the Zinzendorf was home to several families. Merchants who lived away from downtown sought refuge here during the winter months.

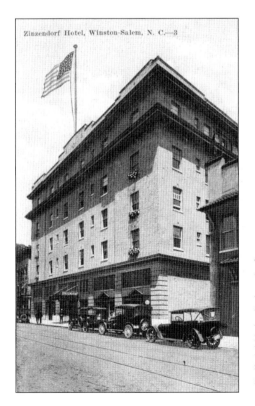

The Zinzendorf Hotel After Addition. The original hotel featured an open front porch. A 40-room addition in 1917 claimed the porch and brought the hotel close to the sidewalk on Main Street. E.W. Dunham was hired as manager in 1932 and later bought stock in the hotel. The Dunham family eventually owned 90% of the stock, and Wallace Dunham followed his father as manager. The hotel closed in 1970.

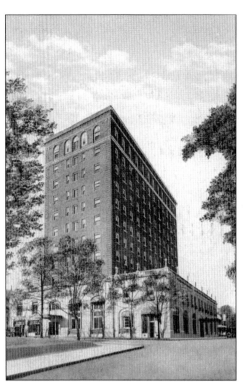

THE ROBERT E. LEE HOTEL, EARLY VIEW. In 1919, when Winston-Salem led the state in population, local business leaders decided that the growing city needed another hotel to accommodate visitors. The group organized the Winston-Salem Hotel Company and built a hotel on West Fifth Street, between Cherry and Marshall Streets. This card was mailed in 1923, just two years after the Robert E. Lee Hotel opened.

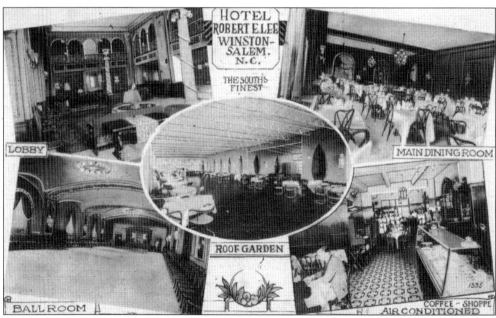

THE ROBERT E. LEE HOTEL, INTERIOR VIEW. The original building was 11 stories tall, with 200 rooms, and cost $1.25 million. Special features included marble floors, Tiffany manufactured lighting fixtures, and mahogany furniture made in Winston-Salem by the B.F. Huntley Company. The writer of this card, mailed in 1938, was writing home to report that she had arrived in town and was staying in this hotel.

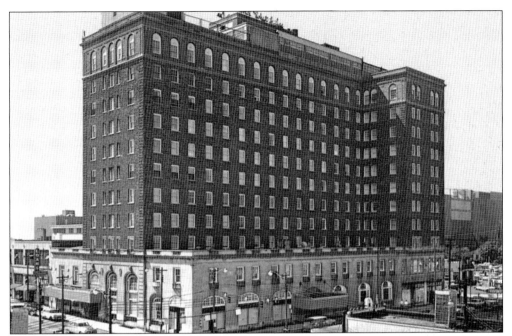

THE ROBERT E. LEE HOTEL, AFTER ADDITION. In 1929 a 138-room addition to the hotel expanded its presence on Marshall Street. Over the years, the hotel received national recognition as a well-run facility with excellent accommodations and food. Many well-known guests, including Gen. Dwight D. Eisenhower and every North Carolina governor who served during its existence, visited the Robert E. Lee. The hotel closed in 1971 and was imploded in 1972.

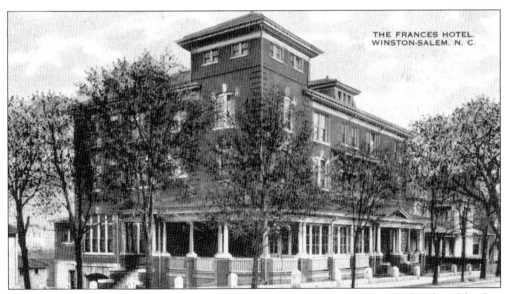

THE FRANCES HOTEL. Col. H. Montague came to Winston in 1886. He abandoned his law practice because of defective eyesight and specialized in office procedures, such as negotiating loans. He undertook the building of the Frances Hotel in 1910 on the southeast corner of Third and Cherry Streets. Designed to have 40 rooms, all well-lighted and ventilated, the hotel catered to families and select boarders. (Courtesy of Sarah Murphy McFarland.)

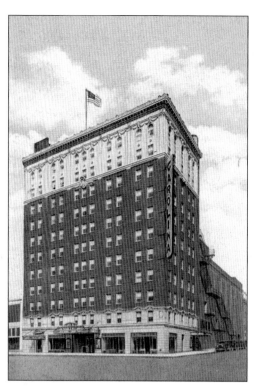

THE CAROLINA HOTEL AND THEATRE. The 11-story apartment house and 3,000-seat theatre on the corner of Fourth and Marshall Streets was an ambitious project for Winston-Salem in 1929. The apartment house soon changed to a hotel, and the Carolina Theatre began its 46-year history as the grand theatre with elaborate lighting, elegant staircases, comfortable lounge rooms, and a pipe organ. (Courtesy of Clarke and Della Stephens.)

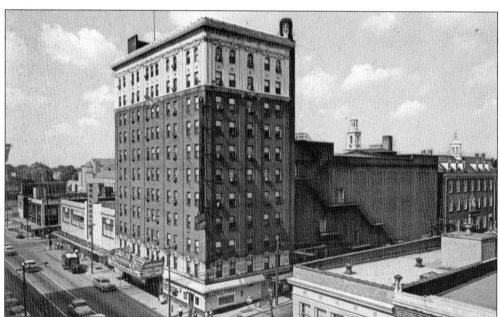

THE CAROLINA HOTEL AND THEATRE. Early theatergoers saw John Barrymore in his first talking picture, *General Crack*. The Sun Drop Cola Kiddie Show on Saturday mornings cost 25¢ or an empty Sun Drop Cola bottle. Local bands provided music for dancing on stage before the children's movie began. Morris Service Restaurant, next to the theatre, was a popular stop for a meal or snack after the movie.

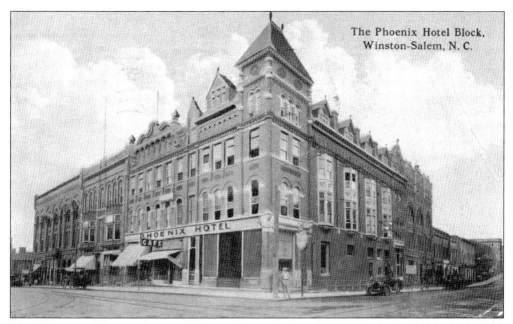

The Phoenix Hotel Block,
Winston-Salem, N. C.

THE PHOENIX HOTEL BLOCK. "The smallpox are close by," penned the writer of this 1913 card mailed from Mocksville. The Phoenix Hotel, the subject of this card, spanned the southwest corner of Liberty and Fourth Streets and occupied the second and third floors of several adjacent buildings. The hotel opened in 1893 and was expanded and refurbished in 1910, offering rooms for 50¢ and upwards, depending on the location.

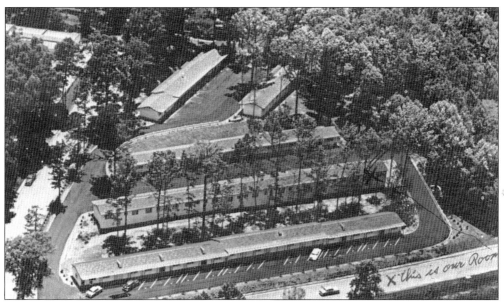

KEMBLY INN. One of Winston-Salem's first motor hotels opened on Cloverdale Avenue in 1950 with 50 rooms. Additions to the motel over the years added 30 rooms and a swimming pool. The modern, rambling hotel was a new look for the city, and for nine years it served unchallenged. In 1963 after other motels opened, Baptist Hospital bought the inn to provide housing for paramedical students. (Courtesy of Sylvia Yarnell.)

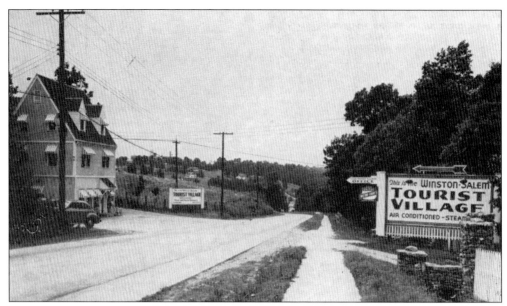

THE WINSTON-SALEM TOURIST VILLAGE. Located on the Old Greensboro Road, the Winston-Salem Tourist Village advertised that visitors could "sleep in safety and comfort without extravagance." The advertisement also touted the "modern cottages and rooms, with private baths and free garages." The tourist village was owned by United Motor Courts and was managed at one time by Charles A. Dobbins, who also managed the Summit Street Pharmacy. (Courtesy of Clarke and Della Stephens.)

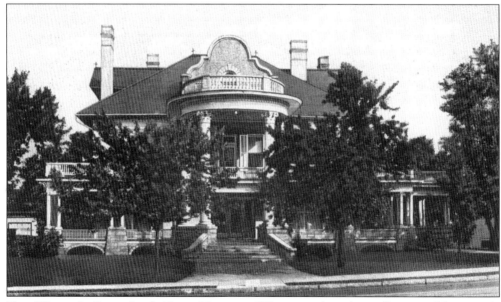

THE WOMEN'S CLUB. Jacob Cicero Tise was a Winston native who made successful careers in merchandising and real estate. He lived at 952 West Fourth Street, near Glade Street, until his death in 1917. The Women's Club was founded in 1919 and met at the YWCA and the Robert E. Lee Hotel. The Women's Club bought the house from Mrs. Tise in 1925 for their clubhouse. (Courtesy of Evelyn Shaw Styron.)

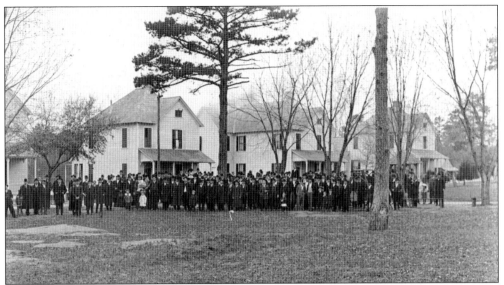

EARLY BUILDINGS AT THE METHODIST CHILDREN'S HOME. The Children's Home opened September 13, 1909, on the land formerly occupied by Davis Military School, on what would become Reynolda Road. The buildings shown in this postcard were used by the Davis School and later by the Children's Home, until funds were raised to build new accommodations. The Davis buildings were repaired and enlarged, but they were finally demolished around 1917.

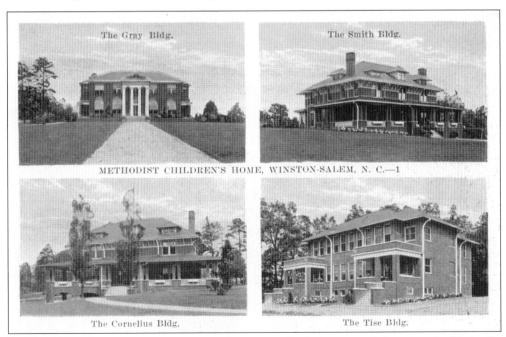

THE METHODIST CHILDREN'S HOME. This is one of at least two cards featuring the Methodist Children's Home buildings on Reynolda Road. The buildings shown here are Gray, Smith, Cornelius, and Tise. The Gray Building served as the dining room, kitchen, sewing room, and dormitory for the kitchen girls and matrons. The Smith and Cornelius Buildings had "cottage-style" accommodations. The Tise Building, financed by Cicero Tise, was the newest of this group.

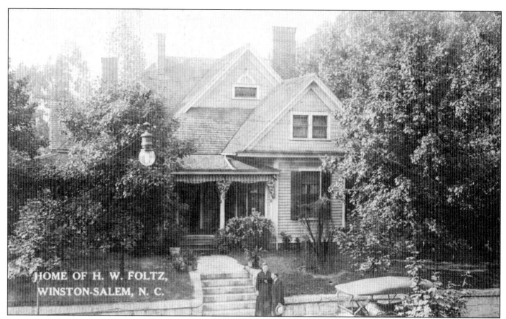

HOME OF H. W. FOLTZ,
WINSTON-SALEM, N. C.

THE HENRY W. FOLTZ HOUSE. When Henry Foltz came to Winston in 1875 from Friedberg, the town so impressed him that in 1925 he wrote "Winston, Fifty Years Ago," which provides a tour of the town from his recollections. Henry Foltz worked in a general store, a tobacco factory, real estate, and insurance. This postcard shows Henry and Carrie Foltz in front of their house at 622 West Second Street.

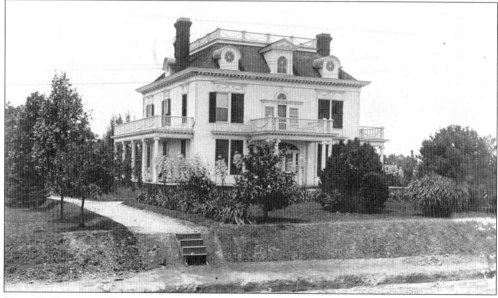

THE J. LINDSAY PATTERSON HOUSE. The writer of this 1910 postcard asked if her correspondent recognized this place and if she was "ever over that way." The writer identified the house as Mrs. J. Lindsay Patterson's "Bramlette." Lucy Bramlette Patterson married J. Lindsay Patterson (no relation) in 1888. They later built a house at the end of Depot Street. Part of the street became Patterson Avenue about 1910.

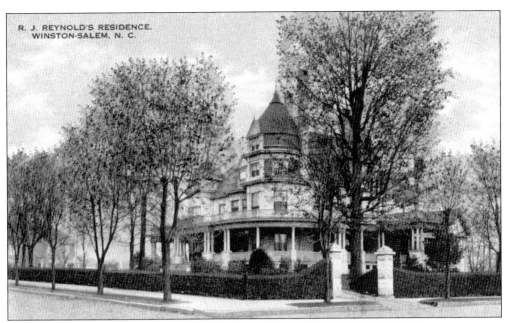

THE RICHARD JOSHUA REYNOLDS HOUSE. West Fifth Street was often referred to as Millionaire's Row because of the large, grand homes that lined the street. R.J. Reynolds built his home at the corner of Fifth and Spring Streets and lived there until he moved to his new home at Reynolda in 1917. The house was well known for its spacious porch and stylish furnishings. (Courtesy of Clarke and Della Stephens.)

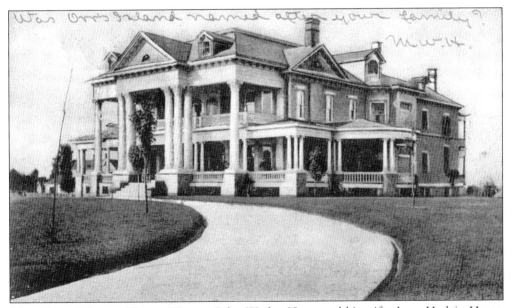

MRS. JOHN WESLEY HANES HOUSE. John Wesley Hanes and his wife, Anna Hodgin Hanes, built this large, grand home, called "Westerleigh," at 953 West Fourth Street. Mr. Hanes' poor health prevented the family's move into their new home until after his death in 1903. Mrs. Hanes and her eight children moved into their new home, which she occupied until about 1923. C.G. Hill and his family lived here later.

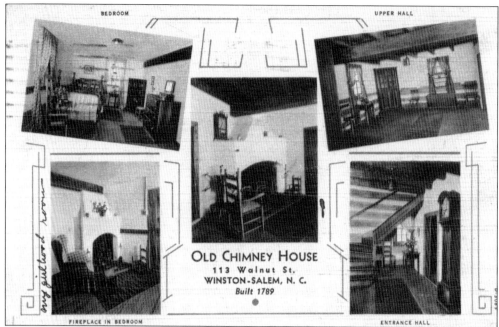

THE OLD CHIMNEY HOUSE. Abram Loesch built his 1789 house on Walnut Street. The house had several owners until Mrs. T.W. Davis bought it in 1913. She renovated, furnished the house in antiques, and opened it to the public. The Coca-Cola Bottling plant on Marshall Street needed expansion space in 1959, so the house was sold, disassembled, and trucked to Chattanooga to be reassembled by the new owners. (Courtesy of Clarke and Della Stephens.)

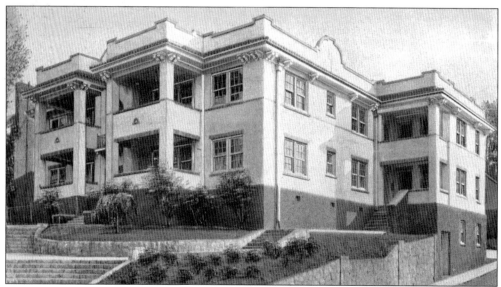

SHENANDOAH APARTMENTS. The large and stylish apartments at 72 West End Boulevard were built about 1924 near Chatham and Buxton Streets. In their earliest days, the occupants of the apartments numbered about six individuals or families. The apartments were designed by C. Gilbert Humphreys of Winston-Salem and owned by Edward Wright Noble, who lived in the house next door. (Courtesy of Sherry Joines Wyatt.)

Nine
RECREATION

Entertainment in the early days of Winston took many forms—a baseball game featuring the Winston Blues, a friendly golf outing with the Twin City Golf Club, and picnics at Southside and Nissen Parks. Fries Manufacturing and Power Company purchased the street railway system in 1900 and expanded the track area to cover more of the city. Nissen Park was built near Waughtown by the streetcar company and featured a zoo, miniature train, wildlife trails, gardens, and a pavilion. There was also a roller skating rink called the "Box Ball" and lots of room for picnics and social gatherings.

The arrival of the automobile opened more avenues for entertainment, as residents could venture out from the downtown area and away from the confines of the streetcar tracks to enjoy the variety of recreational offerings that Winston-Salem made available to residents.

REYNOLDS PARK. On June 1, 1940, Reynolds Park was dedicated to the "entertainment, health, and happiness of the people of Winston-Salem." Residents admired the 18-hole golf course, swimming pool, tennis courts, gymnasium, stadium, amphitheatre, and wooded areas for strolling and picnicking. Land for the park was donated by R.J. Reynolds Jr., his sisters, and W.N. Reynolds. They also provided the sponsors' funds to obtain the WPA project.

GRACE COURT PARK. The small park in West End has a long history in Winston-Salem. It was built in conjunction with the Zinzendorf Hotel on Glade Street, flanked by Fourth and Fifth Streets. When the hotel burned in 1892, hotel guests and employees carried salvaged furniture and belongings to the park and watched the fire. Beautification projects over the years have added a gazebo, benches, fountains, flowers, and trees.

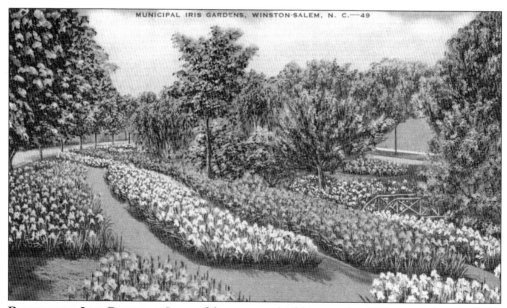

RUNNYMEDE IRIS GARDENS. Some of the pretty, colorful postcards of Winston-Salem show the Runnymede iris gardens in full bloom. This postcard refers to the "municipal" iris gardens and the back of the card mentions the 20,000 colorful plants in the garden. Weeping willows and rustic bridges, plus the flowers, made these gardens a showplace along Runnymede Road. (Courtesy of Clarke and Della Stephens.)

118

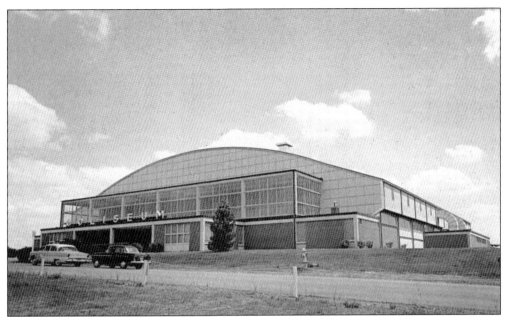

THE WAR MEMORIAL COLISEUM. Charlie Norfleet cut the ribbon on September 19, 1955, to officially open the coliseum and to begin an eight-day run of the Ice Capades. The coliseum was built as a living memorial to the World War II soldiers who gave their lives in service to our country. The coliseum on North Cherry Street hosted basketball games, the circus, rodeos, wrestling, and many entertainers before closing in 1989.

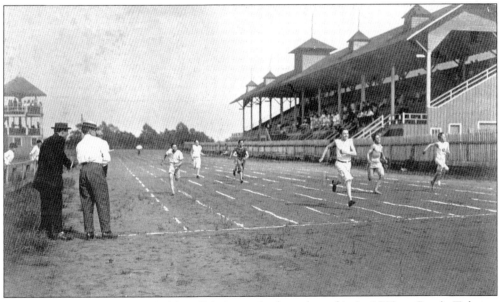

THE FAIRGROUNDS. Rosa Mickey Fries organized a wheat fair in 1882 at Pace's Tobacco Warehouse on North Liberty Street. The fair was so popular that it continued to be held, with the scope gradually widening to include many agricultural products, including tobacco, which was a growing industry. The Piedmont Park Company was formed in 1899 and built the grandstand, track, and other facilities on North Liberty Street, operating there until 1950.

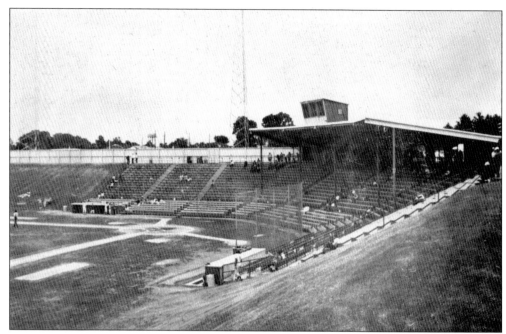

ERNIE SHORE FIELD. Professional baseball came to Winston-Salem in 1905, with early teams playing at Southside Ballpark. Team names and affiliations have changed over the years, from the Twins, Cardinals, and Spirits, to the Warthogs of 2004. Southside Ballpark burned in 1955, and plans began for a new park. Former baseball pitcher Ernie Shore led the campaign and raised money for the park that was later named in his honor. Ernie Shore, a Forsyth County sheriff, pitched for the Boston Red Sox in 1917 and threw a perfect game against the Washington Senators. Charles Babcock donated the land, which was a naturally-shaped partial bowl. Fans entering through the gates of the stadium have a striking upper-level view of the field. The park opened in April 1956 and continues to be the home of baseball in Winston-Salem.

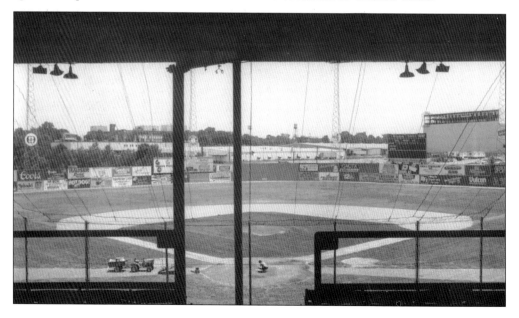

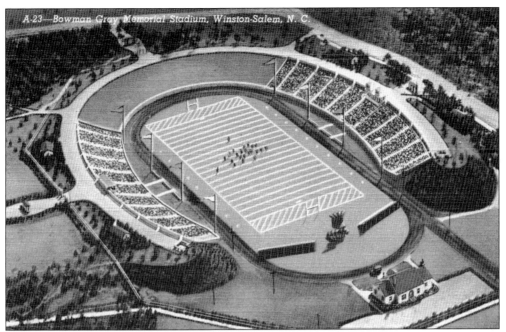

BOWMAN GRAY MEMORIAL STADIUM. At the time of his death in 1936, Bowman Gray was chairman of the Board of R.J. Reynolds Tobacco Company. His family contributed funds for a new stadium, which later became a WPA project. The groundbreaking took place on March 21, 1937, and the stadium was dedicated during a football game between Duke and Wake Forest on October 22, 1938. Duke won the game, 7-0, but Wake Forest played and won many other games in the stadium, the home field for several years. High schools also played their football games at the stadium, which was enlarged in 1954. In addition to football, the stadium hosted midget auto and stock car races, Camel Caravan shows, and the Tobacco Farmers' Christmas party. The stadium continues to schedule sporting and entertainment events during the year.

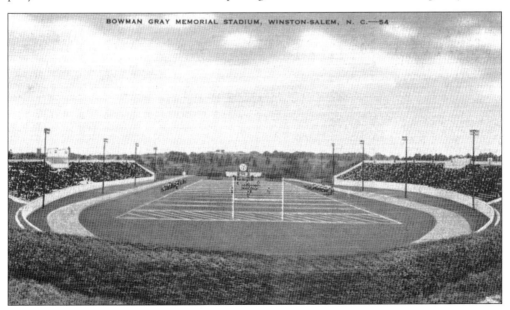

BOWMAN GRAY MEMORIAL STADIUM, WINSTON-SALEM, N. C.—54

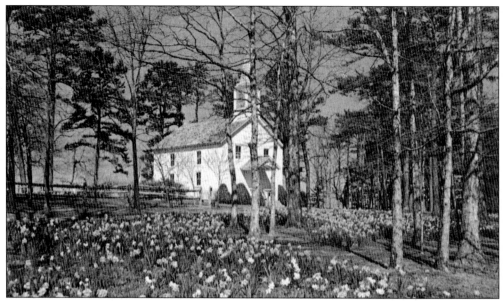

TANGLEWOOD PARK. Mt. Pleasant Methodist Church is the oldest Methodist church building still standing in Forsyth County. The church was built in 1809 on the highest hill in the Tanglewood area, taking its name from the hill. When William Neal Reynolds purchased the church and cemetery in 1929, he moved the church down the hill and used it as a granary. It was returned to its original location in 1956. The name "Tanglewood" was given to the farm by the previous owners, the Thomas Wharton Griffith family. The tangled underbrush reminded the mother of Hawthorne's "Tanglewood Tales," which she read to her daughters. Thomas Griffith was a descendent of William Johnson, the original owner of the tract that became Tanglewood Park. The brick home that was built on the estate for Thomas Griffith's mother was incorporated into the Manor House, where Mr. and Mrs. Reynolds lived.

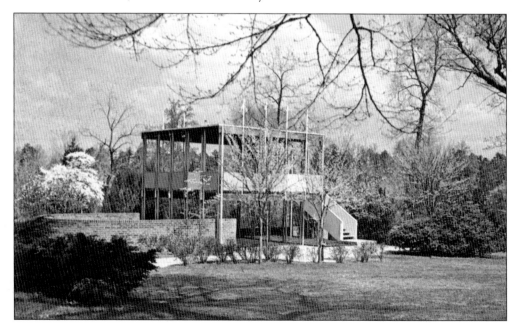

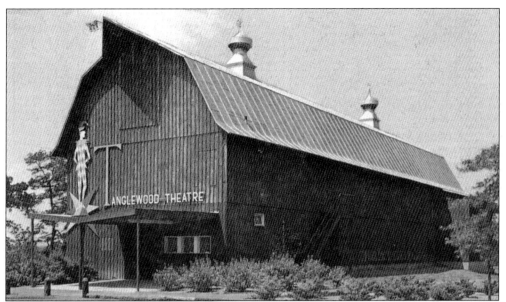

TANGLEWOOD PARK. William Neal Reynolds purchased Tanglewood farm from Thomas Griffith in 1921 and later bought additional land from his neighbors. Mr. and Mrs. Reynolds lived on the estate until her death in 1946 and his in 1951. They bequeathed the Tanglewood property to the people of Forsyth County to be developed as a park. Tanglewood Park opened in 1954 with a multitude of entertainment possibilities: family picnic areas with shelters and grills, bridle and nature trails, riding horses, tennis courts, concession stands, a deer park, overnight camping sites, day camps, and a children's center for arts and crafts. Mallard Lake was developed later for fishing and boating. An ancient barn on the property became the popular Tanglewood Barn Theatre, and a golf course and clubhouse were built in 1958. Other features of the park included a swimming pool, miniature golf course, and a real locomotive.

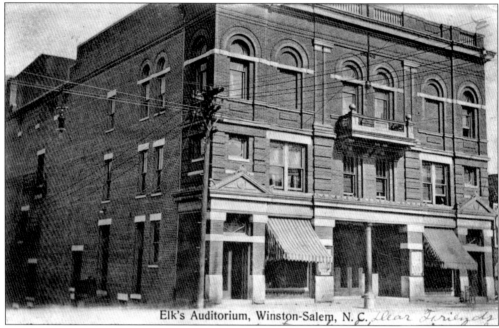

Elk's Auditorium, Winston-Salem, N. C.

THE ELKS AUDITORIUM. Plans for the auditorium, on the corner of Liberty and Fifth Streets, were underway as early as 1902 by the Elks Home and Auditorium Company. On September 24, 1903, the Elks Auditorium officially opened with a minstrel and comedy show featuring local talent, and the Forsyth Riflemen. Opening night tickets sold for $1.00 and were reduced to 25¢ and 30¢ when the show was repeated for the second night.

PICNIC PARTY STARTING FOR THE MOUNTAINS. In the days before automobiles, fun-seeking Winston-Salem residents harnessed their horses and headed to the mountains. The writer of this postcard said that this was a mountain trip that someone else went on. The writer went on the river trip. The members of this group have watermelons in their arms, but their attire suggests that the entertainment for the day was rather subdued.

Selected Bibliography

Bynum, Flora Ann L. *Old Salem Garden Guide*. Winston-Salem, NC: Old Salem, Inc., 1979.

Clewell, John Henry. *History of Wachovia in North Carolina*. New York: Doubleday, Page & Company, 1902.

Crews, C. Daniel, and Richard W. Starbuck. *With Courage for the Future: The Story of the Moravian Church, Southern Province*. Winston-Salem, NC: Moravian Church in America, Southern Province, 2002.

Davis, Chester S. *Moravians in Europe and America, 1415–1865: Hidden Seed and Harvest*. Winston-Salem, NC: Wachovia Historical Society, 2000.

East, Bill. *"Do You Remember?" Series. Winston-Salem Journal*. 1956–1964.

East, Bill. *"POSTscript" Series. Winston-Salem Journal*. 1978.

Foltz, Henry W. *Winston Fifty Years Ago*. 1926.

Fries, Adelaide, Stuart Thurman Wright and J. Edwin Hendricks. *Forsyth, The History of a County on the March*. Revised Edition. Chapel Hill, NC: University of North Carolina Press, 1976.

Griffin, Frances. *Old Salem: An Adventure in Historic Preservation*. Revised Edition. Winston-Salem, NC: Old Salem Incorporated, 1985.

Hall, William James and Helen Johnson McMurray. *Tanglewood: Historic Gem of Forsyth County, N.C.* 1979.

Historical Sketches of P. H. Hanes Knitting Company. Winston-Salem, NC: October, 1934.

Niven, Penelope and Cornelia B. Wright. *Old Salem: The Official Guidebook*. Winston-Salem, NC: Old Salem, Inc., 2000.

Robbins, D.P. *Descriptive Sketch of Winston-Salem; Its Advantages and Surroundings*. Winston, NC: Sentinel Job Print, 1888.

Rondthaler, Rt. Rev. Edward. *The Memorabilia of Fifty Years, 1877 To 1927*. Raleigh, NC: Edwards & Broughton Company, 1928.

Taylor, Gwynne Stephens. *From Frontier to Factory; An Architectural History of Forsyth County*. Second Edition. Winston-Salem, NC: City-County Planning Board of Winston-Salem and Forsyth County, 1982.

Tilley, Nannie M. *The R.J. Reynolds Tobacco Company*. Chapel Hill, NC: University of North Carolina Press, 1985.

Tinsley Military Institute. Catalogue 1910–1911 and Announcements for 1911–1912. Winston-Salem, NC: Barber Printery, 1911.

Tursi, Frank V. *Winston-Salem: A History*. Winston-Salem, NC: John F. Blair, 1994.

Weaver, C.E., ed. *Winston-Salem "City of Industry."* Winston-Salem, NC: Winston Printing Company, 1918.

Winston-Salem in History Series. 13 volumes. Winston-Salem, NC: Historic Winston, 1976.

"Winston-Salem, N.C." Souvenir Edition of Headlight; Sights and Sounds Along the Norfolk & Western Railway. Roanoke, VA: The Stone Printing and Manufacturing Company, 1899.

Winston-Salem, N.C. Winston-Salem, NC: Chamber of Commerce, June 15, 1925.

INDEX

I AM PUTTING ON SOME SPEED IN WINSTON-SALEM. This novelty postcard was mailed in 1913, the year that Winston and Salem officially joined to become Winston-Salem. The writer of the postcard, who lived on North Liberty Street, commented that he had been bedridden for three weeks because he "got hurt at the shop." Novelty cards such as this were printed for many cities and personalized with the city's name.